Historic Crimes of
LONG ISLAND

Historic Crimes of
LONG ISLAND
– MISDEEDS –
FROM THE 1600s TO THE 1950s

KERRIANN FLANAGAN BROSKY

Foreword by Joan Harrison

THE
History
PRESS

Published by The History Press
Charleston, SC
www.historypress.net

First published 2017

Manufactured in the United States

ISBN 9781467137645

Library of Congress Control Number: 2017940948

This book is dedicated to friend, colleague, former professor and history partner in crime Joan Harrison.

Contents

Contents

Foreword

The macabre, the deviant and the unexplained innately fascinate human beings. Crime stories both true and imagined have transfixed the populace from the illustrated Penny Dreadfuls of the nineteenth century to the myriad TV, cable and online series that form the most popular genre today. Indeed, if you look deeper, the Bible and the mythologies of various world cultures are filled with tales of heinous crimes and often explore the dark side of humanity.

In this book, Kerriann Flanagan Brosky presents twenty historical accounts of passion, murder and scandal that were reported in the tabloids of their day, provided fodder for local gossips and often bloodstained the very soil of our communities. This meticulous author investigates not only misdeeds and the events that led up to them but often the aftermath of the crime and its ramifications for society. These vignettes of transgression and wickedness run the gamut from a look at a hanging gone wrong that called into question capital punishment to the mysterious "drowning" of a beautiful young socialite that inspired the novel and subsequent movie *Butterfield 8*.

Kerriann Flanagan Brosky and I have been friends and cohorts in creativity for more than a quarter of a century. We were both mentored by the great photojournalist Arthur Leipzig, who taught us to use our cameras to take a deeper look at the human comedy as well as human tragedy. Both of us went on to apply the lessons we learned from him to our art, our writing and our lives, as well as our image making.

I met Kerriann when she was a young student in my freshman Foundation in Art class. She evidenced a maturity and attention to detail extraordinary for one so young and innocent. I watched as she matured, started her own business, had a family and became one of Long Island's best-loved authors. I enjoyed her local histories, her cookbook, her novel and her amazing books on ghosts and the supernatural. Kerriann was a frequent visitor to my art classes at LIU Post, where her accomplishments provided inspiration and set an example for the students.

Having compiled and written four local histories myself, in my research I frequently came across great stories that did not quite fit into the template I was working with. I knew from my lectures the public was eager and ready for literature that plumbed the depths of the human psyche, and I had to explain more than once why there were no murder stories included in my Images of America and Modern America histories. It was my great pleasure to share the hidden gems I found with Kerriann and watch as she dug for the deeper facts and wove them into tales that did and will thrill her readers.

In this book, the account of Captain James Craft's bone-chilling fate was one I found deep in the annals of the *Brooklyn Daily Eagle* and always wanted to see in print again. I am glad that Kerriann was equally captivated by this gold-toothed dandy and was able to rewrite the voluminous newspaper saga into something the modern reader can absorb. We are both glad that the actual depraved act itself took place in Manhattan and not too close to home for comfort!

During our discussion of the book, Kerriann mentioned that there were no photographs relating to some of the events that took place in the nineteenth and early twentieth centuries and that she needed to find an illustrator. Intrigued, I offered to put my brain and drawing hand to the task. It was quickly decided that pen-and-ink sketches in the tradition of the bloody Penny Dreadful style of illustration would be the most appropriate solution. As an artist who moves back and forth between the drafting table and the camera, this was not such a stretch for me. My first paying job in the arts was as an illustrator of news graphics for Channel 11 New York nightly news, in "tabloid central," the Daily News building on Forty-Second Street. My second was in the WOR TV NEWS studio located over a porn theater in the heart of Times Square, which in the 1970s was one of the raunchiest, most crime-ridden areas of the city. This was the end of the era before computers and video, when Manhattan Island was still authentic and at its grittiest. News cameramen, like the early illustrators, were told to "get shots of the blood on the sidewalks." If they came back empty-handed, the

artists had to come up with a visual solution. Graphics of downed figures, blood spatters and guns were popular.

After years of teaching and making lush landscape pastels as a fine artist, it was great fun to get back to my early roots. It was both mind expanding and challenging to try to tell sometimes-complicated narratives in small monochromatic drawings. What was even more fun was that today's technology allowed me to add additional figures, clean up misplaced lines and edit the work on the computer, an option unavailable to artists when I began in the profession.

The kind of tragic and operatic parables of human wickedness and ill fate found in these pages have informed, educated and entertained people throughout the ages. I hope that you, as a reader, will settle into a big comfortable armchair by a fire to be amazed and chilled by them.

—Joan Harrison
Professor Emerita, LIU Post

Preface

We should pass over all biographies of "the good and the great,"
while we search carefully the slight records of wretches who died in prison,
in Bedlam, or upon the gallows.
—Edgar Allan Poe

Why are people fascinated with crimes? Every day our newspapers are filled with stories of true crimes. Crimes are also fictionalized in novels, with murder mysteries being one of the top literary genres. So what is it about these tales of tragedy, murder and crimes of passion that has us glued to every word we read on the page?

As humans, we are inquisitive about everything, especially things we do not understand, like what motivates another person to commit a heinous act. What is it that leads someone to murder a person out of jealousy, anger or rage? It is difficult for us to comprehend these things. We are also interested—or maybe nosy is a better choice of words—in what goes on in other people's lives. When we read about crimes, we find out what goes on behind closed doors. How shocking it is when we find out someone has been having an affair or a respectable member of the community committed murder. We become obsessed with *why*.

The other thing about crime is that there is often mystery surrounding it. People love a good puzzle to solve, a good whodunit. As you read this book, you will discover several mysteries that have never been solved—murderers who got away. You will have to draw your own conclusions as to what you believe may have happened.

Then there is justice. When we truly know that a wrong has been done, we want to see justice prevail. We want the killer caught. We want to see him or her pay for the crimes committed.

If I didn't write these twenty stories here, they may have been lost forever. Many of them were sensational crime stories in their day, but as years, decades and centuries go by, they are often long forgotten. In writing this book, I have resurrected them and given a voice once again to the poor victims.

The amount of research I did for this project was quite intense. Most of what I uncovered came from old newspaper articles and other documents. Making heads or tails of what happened was often very challenging. First of all, nothing written was condensed. Newspaper articles were enormously long at times, especially when it came to crimes. Every detail from a trial was rewritten as if you were sitting there right in the courtroom. The other interesting thing, as you will see if you check out my bibliography, is that the authors of the articles were never, ever listed. Another challenge was piecing information together from various sources. The amount of inconsistencies and flat-out errors I encountered was baffling. But think about it: in the 1800s and early 1900s, there was no e-mail or fax machines and very few telephones. So how did a newspaper in Chicago find out and write about a crime that took place in Huntington, New York? Things got lost along the way in translation. In the 1600s and 1700s, it was even more challenging because there is virtually nothing original left over from those periods.

I have done my best not to continue historical inaccuracies, and I believe I am giving you the true stories to the best of my knowledge. At times, if I could not figure out if something was accurate or not, I will state my uncertainties and why.

As a historian, I was pleased when my publisher asked me to take on this project for its Murder and Mayhem series. It was obviously different from what I've been doing for years with my *Ghosts of Long Island* books and my most recent *Historic Haunts of Long Island*, but research is research, and I loved every bit of writing this book.

From Captain Kidd and the East Hampton witch trial in the 1600s to the famous Woodward murder of the 1950s, this book has it all—pirates, witches, jealousy, revenge, tar and feathering, beheadings, drownings, madmen, eccentrics, axe murderers and more. I have discovered that not much has changed, unfortunately, between then and now. There are bad people and there are good people, and the things that drive people to commit crimes today are the same things that drove people to commit crimes way back when.

The only difference in most cases was how justice was handled. I learned a lot about the law, capital punishment, forensics and trials. Back in the day of the East Hampton witch trial, there were three possible verdicts, not two. You could be found guilty, not guilty or innocent. One of my personal favorites is how they caught the murderer in the Hawkins story, which took place in Islip. A farrier was able to identify tracks left at the murder scene from a horse he had recently shod. He recognized the imprint of the particular horseshoe he had used, which led to the murderer. What I love about historical research is that there is always something new to learn or discover.

I was asked while investigating and writing my ghosts books if I was ever scared. Believe it or not, I found writing this book more chilling in many cases, because the crimes seem to come to life on paper, and I'd find myself having to step away from it from time to time.

They are stories that need to be told nonetheless, so I share them with you today, in all their gruesome and bloody details.

Acknowledgements

Writing a book of this nature would not be possible without the help of other historians who I have been honored to work with over the years. Their knowledge and assistance has been invaluable to me, from helping me come up with the stories to finding images for me to use. It has been a pleasure, as always, to work with each of you: Barbara Johnson, local history librarian, Northport–East Northport Public Library; Brenda Sinclair Berntson, president, Hampton Bays Historical Society; Deanne Rathke, director, Greenlawn-Centerport Historical Society; Gina Piastuck, department head, Long Island Collection East Hampton Library; Iris Levin, archivist, Nassau County Photo Archives Center; Julie Greene, collections manager, archivist and curator, Bridgehampton Museum; Karen Martin, archivist, Huntington Historical Society; Laurie Collins, program and education coordinator, Southampton Historical Museum; Linda Paris, journalist; Mary Cummings, research center manager, Southampton Historical Society; Natalie A. Naylor, president, Nassau County Historical Society; Officer Raymond C. Mahdesian, chief of Asharoken Police Department; Philip Blocklyn, executive director, Oyster Bay Historical Society; Richard Barrons, executive director, East Hampton Historical Society; Robert C. Hughes, Huntington Town historian; Steve Boerner, local history librarian, East Hampton Library; Tracy Pfaff, executive director, Northport Historical Society; Victoria Berger, executive director, Suffolk County Historical Society; Wendy Polhemus-Annibell, reference librarian, Suffolk County Historical Society.

To Joan Harrison, you saved the day with your fantastic sketches! I cannot thank you enough for volunteering your time to do them. Thank you for recommending several of the stories to me and for pointing me in the right direction for research. To have your expertise and input in this book has been truly wonderful. Who would have thought in 1986 we would be at this point today and still working together? It's been great fun and also an honor. Arthur would have been so pleased. We are connected because of him.

To my acquisitions editor at The History Press, J. Banks Smither. It has truly been a pleasure working with you.

To Hilary Parrish, senior editor at The History Press. Thank you for your editorial skills and for making my manuscript the very best it can be.

To my mother, Deanna Flanagan, for your constant support and encouragement.

To my sons, Ryan and Patrick, thank you for giving me the time and space I need to write. I am so proud of the writers you have become. To Michaela, you will always be a part of this family. Thanks for believing in me.

Finally, to my husband, Karl, my partner through all the good and all the bad and everything in between. You have always taken the journey with me and have been so supportive and understanding throughout my career. Your unfailing belief in me has always kept me going. I am most grateful.

For my friends and family in spirit. Even from the other side, you continue to help me along my path in remarkable ways.

The Tarring, Feathering and Murder of Charles G. Kelsey

HUNTINGTON

On November 4, 1872, a crime occurred in Huntington that shocked not only the town but the entire nation. The story began with beautiful Julia Smith, daughter of the influential Smiths of Huntington. Julia lived with her grandmother Charlotte Oakley in a large clapboard house that was located on Main Street near Spring Street, now Spring Road. An old red barn existed behind the house on what is now Platt Place. The barn was in terrible disrepair and was taken down in January 2001, leaving only a historical marker in its place. It was at this site that the first of two crimes took place.

Charles Kelsey, a wealthy farmer, schoolteacher and poet, had fallen in love with the much younger Julia Smith. They were said to have had a brief romance despite Julia's engagement to Royal Sammis, a member of one of Huntington's most prominent families. Julia's family, hearing of the romance, greatly disapproved of Kelsey and told the girl to end the relationship immediately. A brokenhearted Kelsey continued to write letters to Miss Julia that expressed both his anger and his love. Julia's grandmother intercepted many of the letters, so Kelsey went as far as to mail them by way of New York City. This lasted only a short time. Mrs. Oakley began to tell her friends and neighbors (especially Dr. George Banks) about the letters, calling them "obscene" and even accusing Kelsey of enclosing pornography. This was never proven. Some of the letters were given to local reporters, who called them "crazy utterances of a lovelorn idiot."

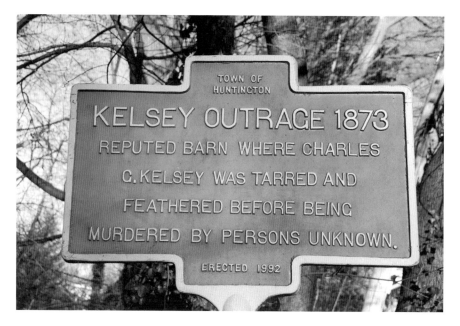

A historical marker designating the site of the tar and feathering of Charles G. Kelsey. *Photo by Kerriann Flanagan Brosky.*

One of Julia's aunts, Abby Smith, was so suspicious of the letters that she decided to switch beds with her niece to see if Kelsey would come calling. Several nights later, while the aunt was sleeping, Kelsey is said to have entered the room through a window and attempted to make love to the aunt, who he believed was Julia. The aunt woke screaming and fled, locking the door behind her. When the aunt and grandmother went back to the room, it was empty, and they surmised Kelsey had left via the window. This tale was never proven, but in Victorian days, no one dared question a lady's word. The story was taken as truth, and so it lived on.

It was this tale that provoked the violence that would soon take place. It was the night of November 4, 1872, the eve of Grant's victory over Horace Greeley in the presidential election. The Democrats were holding a big rally, and many of the local hotels were filled with visitors. Charles Kelsey attended the rally, and when it was over, it appeared that Kelsey was on his way to his sister Charlotte's home, half a mile up Spring Street where Charles lived. At some point, he had arranged a secret meeting with Miss Julia. She was to give him a signal when the coast was clear so he could come and see her. Unfortunately for Kelsey's sake, this was a setup, because his love had forsaken him.

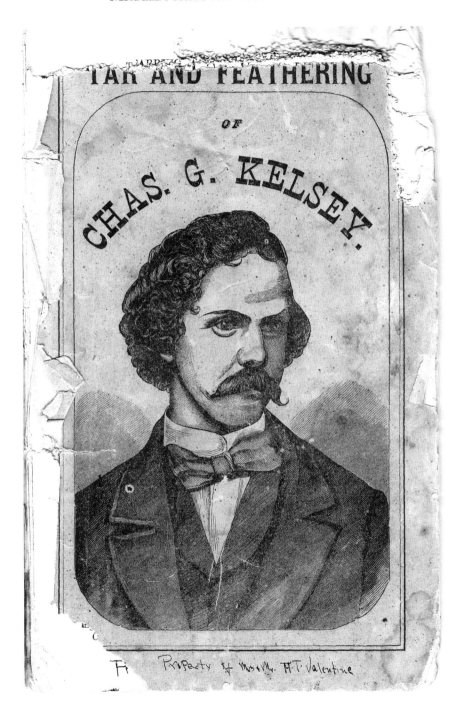

A portrait of Charles G. Kelsey. *Huntington Historical Society Archives.*

Apparently Julia deliberately trapped Charles by waving the lantern in the cellar window, giving her former beau the signal to visit. (Later, in her testimony in front of a jury, Julia admitted that she lured Charles with the lantern.) Upon his arrival, Kelsey encountered a band of masked men who jumped out from the backyard and stripped off his clothes. The men had been hiding beneath the branches of a willow tree, waiting for his arrival. Several of the men dragged out huge buckets of tar, while others brought large bags of feathers. In the barn, they cut off Kelsey's beard and hair, poured the buckets of hot tar over his nude body and then covered him with feathers. Then the men dragged him to the front porch of the Oakley house, where Julia and her grandmother were waiting with some friends. A lantern was shone on poor Kelsey to prove, in the darkness, that it was in fact him. Enraged and humiliated, Kelsey lunged free, throwing his shoe at the lantern to extinguish it. However, one of the masked men grabbed the lantern and smashed Kelsey over the head. Finally, the men gave Kelsey his clothes back, and he ran off to his sister's house.

From this point on, exactly what happened remains a mystery. Charles G. Kelsey simply disappeared. According to his sister Charlotte, she found a tar-covered watch without a chain in the kitchen, and there were signs of a struggle on the front lawn.

The next day, Charlotte and two other brothers, Henry and William, began a search but found nothing. Later that afternoon, a fisherman discovered a blood-soaked shirt on the shore of Lloyd Neck overlooking Cold Spring Harbor. The evidence was brought to the Kelsey brothers, who identified it as Charles's shirt. Setting forth their belief in his death, Henry and William brought the shirt and an affidavit to Justice of the Peace William Montfort. They claimed their brother was "the victim of foul and unlawful treatment," and an inquiry was opened in the village. Justice Montfort, based on the Kelsey brothers' statement, charged Dr. Banks, Claudius B. Prime and Royal Sammis with riotous conduct and assault. The grave charges were sustained by the grand jury in a subsequent indictment.

Within days, all over the East Coast, Huntington was branded with the name "TAR TOWN." The town became the target of every newspaper writer around, and the story spread nationwide. The incident created political problems in Huntington as well, for the once-quiet town was divided into the "Tar" and the "Anti-Tar" parties. The "Tars" were relatively small in number but were wealthy and influential, while the "Anti-Tars" opposed the outrage and held to the principles of law and order. This group was composed of many of Kelsey's friends.

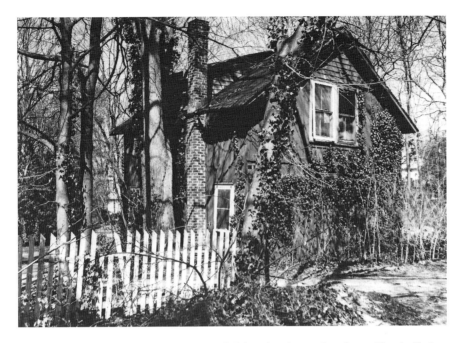

The barn where the Kelsey outrage occurred. It has since been taken down. *Photo by Kerriann Flanagan Brosky.*

It is said that even in his horrible condition, Kelsey recognized some of the masked men. Fearing exposure, the men may have followed Kelsey home and, under the motto "Dead men tell no tales," killed him. In the hopes of concealing their identity, the body was perhaps brought to the deepest spot in the harbor with weights attached, in the hope it would remain out of sight forever.

It was hard for many members of the community to believe that such respectable men could be involved. Some were sympathetic toward the men accused of the outrage and claimed Kelsey deserved the punishment he got. They even believed that he was hiding out elsewhere in the United States and that he would one day return to seek revenge on his enemies.

The town was anxious to clear up the mystery, so Town Supervisor J.H. Woodhull offered a $750 reward for the production of the body of Charles G. Kelsey, dead or alive. The reward was then increased by $500 by Kelsey's relatives.

Months went by with no sign of the body. In the meantime, Miss Julia Smith, seemingly unaffected by the event, married Royal Sammis in June 1873. Three months later, a grisly discovery would be made.

On August 29, 1873, fishermen John A. Franklin and William B. Ludlam were in two small boats in Oyster Bay when they noticed something strange floating in the water. Upon closer inspection, it appeared to be the lower portion of a human body. They fastened a line to it and towed it ashore, at which point they notified the coroner. When the body was found, it was covered in sea spiders.

More testimonies were heard, and other witnesses were called to the stand, some of whom included Charles's youngest brother and the medical examiner. William S. Kelsey's testimony was important as to the identification of the legs. He recognized the remains as being those of his brother. The legs had bits of tar and feathers on them, and he recognized the watch chain and the comb that had been on the body. The chain had been in the Kelsey family for twenty years, and the comb was one carried by his deceased brother. The pants could not be recognized by William but were later proven to be Charles's when his tailor testified and proved the work he had done on the pants.

The medical examiner, Dr. M. Cory, gave a grisly account of just how brutal the crime was. In his statement, he said, "On closer examination I found that parts of the anatomy between the pelvis and knees were missing. I am of the opinion that it was the work of violence."

Another doctor testified that the body was so terribly mutilated that it was a deed "expected from savages, not of peaceful Huntingtonians." He believed the body had been weighted down with ropes that were tied around the waist, and the ropes were what cut through the torso.

The "Tar" crowd, despite the testimonies they heard, still argued that the legs were not Kelsey's and that if they were, he had to have committed suicide. This did not stop Kelsey's family from having a funeral service for him. They accepted the remains for burial, believing it was Charles, and preparations were made. To make matters even worse, an unidentified person posted a horrible notice mocking the services to come—the funeral services of "Legs."

The funeral at the Second Presbyterian Church was jam-packed. Never before had Huntington seen such a huge crowd gather for a funeral. The pastor would not permit the legs in the coffin to be brought into the church. They were left outside on the lawn while services were going on. During a sermon, Charlotte Kelsey collapsed and was carried out of the church and into the crowd.

The remains were buried, but Huntington found itself the subject of bitter attacks in the nation's press. Finally, under the pressure of every major newspaper in the state, Governor John Dix in Albany sent his own aide-de-

camp to Huntington to "clean up the mess." He offered a $3,000 reward, an unbelievable sum for the day, for the arrest and conviction of Kelsey's killers. The murder was considered one of the worst crimes of the century.

A coroner's jury continued to hear evidence at the courtroom in Oyster Bay in September through October. (Nassau was then part of Queens County, which had jurisdiction over Cold Spring Harbor.) Coroner Valentine Baylis of Oyster Bay had ordered an inquest to determine whose legs were found and how they got there.

Frederick Titus, a Negro servant in Royal Sammis's family, was a key witness. Under cross-examination, he admitted that Sammis told him he was going to tar and feather Charles Kelsey. However, his memory seemed to fail shortly afterward, and the same was true with the dozens of other witnesses who later took the stand. For years it was rumored that Titus never lacked a home or money to live on.

The jury made a decision on October 25, 1873, although it didn't accuse anyone specifically of homicide. It ruled the "legs" were definitely Kelsey's and that he "came to his death at the hands of persons unknown." It found that "Royal Sammis, George M. Banks, Arthur Hurd, William J. Wood, John McKay and Henry R. Prince aided, abetted, countenanced by their presence committal of the gross outrage and inhuman violence." They also ruled that Arthur Prime, Claudius Prime, S.H. Burgess, Rudolph Sammis and James McKay were accessories before the fact.

The local newspaper, the *Long-Islander*, argued from the beginning that the legs were not Kelsey's and that it was a conspiracy of local politicians and Kelsey's family to discredit some of the best families in town. It also insisted the trouble was being caused by New York City reporters who were "concocting their stories over the hotel bar."

The testimony was finally sent to the grand jury, forty miles away in remote Riverhead. On November 7, 1873, the grand jury indicted Royal Sammis and Dr. Banks for riot and assault, the original charges made against them when Kelsey disappeared. A few hours later, the jury filed an indictment for second-degree murder against Royal Sammis and his brother Rudolph. The evidence provided by the district attorney for murder never showed up in open court. This, too, was a mystery.

Meanwhile, the fishermen finally received the $750 reward, but it cost Supervisor J.H. Woodhull his job. He lost the next election to Stephen C. Rogers because an injunction was filed against him claiming the reward was illegal, despite the orders that had been given to him by the people of the town. He had prepared a special bill for the state legislature to make the

payment. Woodhull not only lost the election but was also forced to pay the $750 from his own funds.

The Sammises and Dr. Banks tried to get their cases transferred to Supreme Court in Brooklyn (Kings County) on the grounds that they could not get a fair trial in Suffolk. By 1874, rumors arose that Charles Kelsey was alive and living in California. It turned out to be Charles's brother George, who had left Huntington twenty-five years before. Three years later, again in Riverhead, a jury hearing the evidence against Sammis and Banks returned a verdict of not guilty. In October 1876, Royal and Rudolph appeared in the same court demanding to be brought to trial or discharged. The district attorney released both men in their own custody with the stipulation that they appear when ordered to. For reasons unknown, the order never came.

Royal and Julia Sammis, Dr. Banks and several other central figures in the case moved to New York City to live their lives in seclusion. Despite search after search, the upper body of Charles G. Kelsey was never found.

The Corn Doctor Murder

QUOGUE

The case of the corn doctor murder is an unusual tale of an eccentric podiatrist, Dr. Henry Frank Tuthill, known as "the corn doctor"; a bootlegging former police officer named Victor Downs; and a former cabaret entertainer named Mitzi Nowak Saunderson Downs.

The bizarre event that led to murder began in the quiet town of Quogue on the East End on the night of August 6, 1932. It was almost three years since the stock market had crashed, and the Great Depression was looming over the nation. The people of Long Island were nervous about putting their money in the hands of the banks. It was not uncommon for many people to hide and carry large amounts of money on their person, stuffed in boots and clothing. Dr. Henry Frank Tuthill was one of those people.

What made Dr. Tuthill a little different is that he was known to tell the world about the money he carried around with him. He was a bit odd, in many ways. He was a practicing chiropodist, which basically is a podiatrist. A chiropodist was a more common word used back then. Dr. Tuthill did not like to be called by his formal name, so he told everyone to refer to him simply as the "corn doctor."

The sixty-eight-year-old doctor was tight with his money. He did not have an office of his own, so he would travel around Quogue and Hampton Bays in an old flivver making house calls and treating people's corns. At the day's end, he'd head home to a room he rented from Mr. and Mrs. Fillmore Dayton in Quogue. Boardinghouses were popping up everywhere, and people would rent rooms rather than rent or buy a place of their own.

Right: A Quogue sign. *Photo by Linda Paris.*

Below: An image of Dr. Henry Frank Tuthill, "the corn doctor," with two of his guns. *The Collection of the Suffolk County Historical Society.*

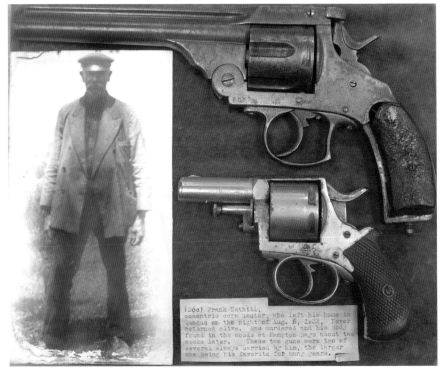

(Doc) Frank Tuthill, eccentric corn doctor, who left his home in Quogue on the night of Aug. 5, 1932. Never returned alive. Was murdered and his body found in the woods at Hampton Bays about two weeks later. These two guns were two of several always carried by him, the larger one being his favorite for many years.

Most people on the east end knew who Henry Tuthill was. No matter what the temperature was, he was always wearing not one but two long, black overcoats. It was in these coats that he would hold up to $30,000 in cash, along with four revolvers. Tuthill was warned once by District Attorney Alexander G. Blue that he really shouldn't walk around with that much cash on him, let alone tell people about it.

Tuthill's response was, "I don't believe in banks, so I'll carry the money on me. Let anybody try to hijack me and they'll soon see where that gets them."

Despite his oddities, the Fillmores liked the corn doctor, and he always paid his rent on time. On Saturday night, August 6, at 10:00 p.m., something unusual happened. Tuthill came to the Fillmores and told them that he was going out to make a professional call. He did not say when he was coming home, but he did say that they should call the police if he was not back in an hour. He left with $10,000 wrapped in soiled envelopes and the four loaded revolvers that he carried in hip and arm holsters. Tuthill did not return within the hour, but Mrs. Fillmore did not notify the police until the next day.

A search party went looking for the corn doctor the next day, and by Monday, August 8, Suffolk County officials called for an airplane fly-over. It wasn't until two weeks later that a Hampton Bays summer resident, Jack Breslin, found the body of Dr. Tuthill in his flivver. The car was parked on a deserted dirt road called Tanglefoot Road that no longer exists but was located off Lynn Avenue in Hampton Bays. When Tuthill's body was found, it was determined through the coroner's examination that Tuthill died from five bullet wounds in his lower stomach and a compound fracture to his skull.

A week or two later, three boys from Central Islip named Robert Story, Willie Julian and Vincent Boyd made a bloody discovery while playing in the woods north of Suffolk Avenue in Central Islip. They found a bloodstained hunting coat, which they brought to two town officers, Thomas Julian and Charles Yezek. The two officers headed to the woods in hopes of finding additional information. They did an extensive search of the area and discovered a pile of what they believed were bloodied articles. There were two floor rugs, three sofa pillows, an empty suitcase that had four bullet holes in it, a black string from a woman's dress, an Indian blanket, a fully loaded English bulldog pistol and an empty .44-caliber old-style Frontier pistol. The items were traced back to a suspicious character named Victor Downs.

Forty-four-year-old Downs, along with his wife, Mitzi, who was twenty-five, and another suspect, Joseph Hojenski, twenty-four, were arrested and charged with first-degree murder and were taken into custody at the Suffolk County Jail, where they were held without bail.

Victor Downs was a shady character who had moved to Riverhead, Long Island, from Virginia, where he had been a police officer. He got involved with bootlegging and apparently was an ex-member of "Big Bill" Dwyer's liquor mob. Dwyer was known as "King of the Rumrunners." Because

of his involvement with the notorious mobster, Downs was disgraced and discharged from the police force. It is unknown what Downs did immediately following the discharge, but it is known that he was often in trouble with the law. He eventually met up with Mitzi Nowak Saunderson, who became his wife and later accomplice to murder.

It is said that the corn doctor knew the Downses. Perhaps it was through Tuthill's work, because it was Mitzi who lured him to their bungalow on the outskirts of Quogue by telling him she had a foot ailment.

This information came to light when the police were questioning Mitzi. They were able to get a full confession from her. Mitzi claimed that "she saw her husband and Doc Tuthill facing each other with drawn revolvers and that the corn doctor was shot in a standing-up duel." She did not say how or when Tuthill's head was smashed from behind. After the murder, Victor robbed him of his cash. As for the bloodied items found in the woods, Mitzi told the police that the day after the shooting, Victor took the items to her mother's house in Quogue and later came back for them. Victor then piled them in his car and said he was taking them "somewhere to hide them."

Joseph Hojenski was then brought in for three hours of questioning. He was known as a "bad boy" around the Riverhead area, and it was believed either that he may have helped move Tuthill's body or that he had "a good lead" on someone else who may have assisted Downs. A businessman, whose name was withheld, came forward stating that he had overheard Downs and Hojenski talking about robbing the corn doctor three weeks before the murder.

After extensive questioning, the assistant district attorney, L. Barron Hill, was convinced that Hojenski was not an accomplice to murder, and he consented to a motion by Hojenki's attorney, J. Harry Saxtien, for the dismissal of the charges. Oddly enough, shortly after Hojenski's release, he was re-arrested on a charge of "possessing brass knuckles" and was thrown back in jail. He remained as a witness in the Downs case.

Meanwhile, investigators discovered that a coil of clothesline found in the Downses' house matched the line that was used to tow Tuthill's flivver to the deserted road. Bloodstains appeared on the floor of the bungalow, and scrapings were taken for analysis. It is unknown whether it was ever proven to be the corn doctor's blood.

Mitzi had agreed to testify against her husband in court, and in return, she was offered a deal that would give her immunity. Shockingly, when it came time for Mitzi to tell her story in court, she started screaming instead,

saying, "You tricked me! You made me lie!" She told the jury that she had been tricked into signing a false statement.

The prosecutor realized that without Mitzi's testimony there was no case against Victor Downs. There just was not enough evidence to prove that Downs murdered Dr. Tuthill, so the charges against Downs were dropped. Some believe that this was an elaborate attempt on Mitzi's part to get her husband off the hook.

Prosecutor L. Barron Hill made other attempts, to no avail, to charge both Victor and Mitzi with first-degree murder. Victor, however, cried double jeopardy and was released from jail. Mitzi, on the other hand, remained in jail because Prosecutor Hill swore he would find a way to use her confession against her. He was not at all happy with the chain of events and the chaos it caused in court. By this point, news of the crime and the dramatic court scene had spread throughout the nation.

Prosecutor Hill might not be able to get Downs on the murder charge, but he could get him for grand theft for stealing Tuthill's money. So Victor Downs was arrested for a second time, but he was quickly released on a bond. Mitzi continued to serve time in jail, and her love for her husband stayed true. She wrote Victor a letter stating her regrets for confessing and offering her apologies with the hopes of his forgiveness. In the letter, she wrote, "Vic, I love you, I love you. Oh! Why did I hurt you? What have I done to you? God forgive me. If I could only right the wrong I have done you. I love you, darling. I will always love you. I will be waiting for you forever. Forgive me, darling. I love and will always love you. Your own Mitzi." Apparently, Mitzi tried to smuggle the letter to Victor by placing it in a Bible, but the prison matron discovered and discarded it.

As for Victor Downs, being out of jail, you would think at this point that he would be on his best behavior. Instead, he went to the home of a Mr. Mike Gallo from Mattituck. It is not known what the meeting was about, but whatever happened, it ended in a violent argument, and Victor attacked and stabbed Gallo, cutting his throat as well.

Victor was arrested yet again and charged with second-degree assault. He ended up pleading guilty to a first-degree assault charge on the condition that his wife would go free. He was then sentenced to ten years in Sing Sing, where, oddly enough, he began to study law.

By the time Victor was paroled, he was a self-proclaimed attorney and insisted on speaking on his own behalf in a Brooklyn Supreme Court. He tried to get himself off the hook by claiming that the courts in Suffolk County had "persecuted him for political reasons" and that he had been "made the

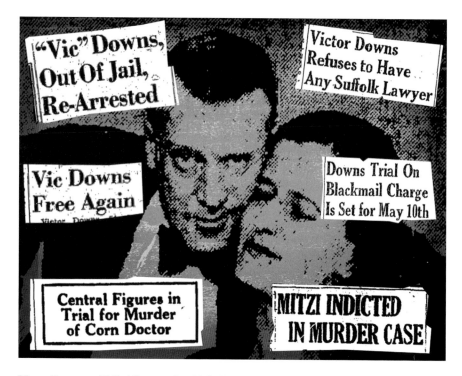

Victor Downs and Mitzi Downs. *Graphic by Linda Paris.*

goat" after his acquittal in the Tuthill murder. His request for parole was denied, so he filed a second request at the Supreme Court in White Plains. This time, Victor Downs was granted parole. After serving only three years in prison, Downs was set free, but it wasn't for long. Prosecutor Hill, hearing of Downs's release, made a case opposing the ruling, and he managed to get Downs back in jail, where Downs would serve his full ten-year sentence. Downs was released on February 4, 1943.

Throughout his years in jail, Victor Downs had plenty of time to think about what Prosecutor Hill had done to him, and Downs's anger grew. After being released from the ten-year sentence, Victor stupidly sent threatening letters to Prosecutor Hill, who was now a judge, as well as to other Suffolk County officials he believed had done him wrong. Judge Hill notified the FBI, which located Downs, charged him with extortion and threw him back into the Riverhead jail.

Victor again made newspaper headlines, especially when he insisted on representing himself in court, where he would plead not guilty to the

charges. The court insisted he use the court-appointed attorney, but Downs would not budge. Because of this, the trial was postponed until the matter could be worked out. Downs was sent back to the Riverhead jail, and bail was set at $50,000.

Victor made a huge fuss, stating he could not get a fair trial in Suffolk County because residents were biased over the corn doctor crimes. He eventually agreed to work with an attorney from Westhampton, and they were granted a change of venue.

A jury in a court in Nassau County dismissed one charge of blackmail but remained undecided on another charge. All the charges were eventually dismissed. Judge Hill continued his quest to get Downs and wanted him retried back in the Suffolk County courts. He had him arrested yet again, but Victor, in his cunning ways, asked a second time for a different venue, which was granted. This led Victor Downs to plea to a lesser charge. He received a suspended sentence on the charge of "sending an annoying letter." Downs had beaten the system.

Unfortunately for poor Dr. Tuthill, it would never be determined who actually murdered the eccentric corn doctor from Quogue.

The Maybee Murders

BROOKVILLE

It was November 1883 when a series of violent robberies and home invasions rocked the quiet farming community of Brookville, leaving a mother and daughter dead and four others seriously injured. The case drew a lot of attention. Several suspects had been arrested and questioned before law enforcement knew who the true murderer was.

On the evening of November 17, 1883, seventy-three-year-old Garret Maybee was in his house while his wife, Lydia, also seventy-three, went to the barn to milk some cows around 4:30 p.m. Having not returned by 5:00 p.m., Garret sent his thirty-nine-year-old daughter Annie to the barn to check on her mother. Garret could not do so himself since ten years prior he had been paralyzed from the waist down when he incurred a massive stroke. Not only was he confined to a chair, but he had also been blind for the past two years.

By 5:30 p.m., neither Lydia nor Annie had come back to the house. Garret became quite concerned, especially when he heard the door open and footsteps in his house that were surely not the footsteps of his wife or daughter.

Garret called out, "Who is there?" and a male voice replied, "Me." The intruder then made his way upstairs. A few minutes later, he came back down and demanded that Maybee give him his watch. Explaining how he was blind, Garret told the man that he no longer wore a watch so he didn't know where it was. The intruder became irate and said, "Then I will kill you." He then grabbed Maybee's cane and proceeded to beat him with it

until he was unconscious. When Garret finally came to, he managed to get the window open and scream for help.

One of his neighbors, Israel Baxter, happened to be walking by and heard the screams. He rounded up some other nearby neighbors, who set out for Maybee's house with shotguns, spades and other weapons, not knowing what they'd be walking into. Upon entering the house, they found Maybee in his chair, bleeding from several cuts on his head. He was dazed and mumbling about his poor wife and daughter. The neighbors began to search the house for them, and when they didn't turn up, they headed quickly to the barn, where they stumbled upon a ghastly site: Lydia and Annie had been strangled and were lying in the corner of the barn covered with leaves.

The little community was in a state of shock over the murder and robbery of such a respectable family. The board of town officers offered a $500 reward to anyone who could identify the killer, and then the Queens County Board of Supervisors added another $500 to the reward. With a $1,000 reward on the line, several people came forward with potential suspects. The first suspect was James Doyle, from Brooklyn, a vagrant who had been seen in the area by Garret Maybee's son-in-law. Apparently a shoe matched a footprint found near the Maybee barn. Another vagrant ("tramps," as they were called in 1883) was also arrested. He was John Brown, who had accused James Doyle of the crime, claiming that Doyle had shown him the bodies of the two dead women.

An inquest began, and several pieces of circumstantial evidence pointed to James Doyle. Garret Maybee was brought in to listen to the voice of James Doyle to see if he could identify it from the voice he heard that treacherous evening. Doyle was told to say, "Me," and "I will kill you." Garret, whose eyesight had temporarily come back after the blows to his head, identified Doyle by voice alone as his assailant. The bodies of the dead women were shown to Doyle, who claimed that he did not recognize them and that he had never been to their barn and did not kill them.

Despite the evidence brought against Doyle, the authorities were not at all convinced that he was their killer. Seven detectives worked on the case, and they determined that revenge may have played a role. If robbery was the only motive, the robber could have simply robbed the house and fled, never going anywhere near the barn. It was also interesting to note that the thief went straight to Lydia and Garret's bedroom, where he removed a cameo brooch, Lydia's watch and $100 from two drawers. Authorities believed the thief knew exactly where to look for these items. He also knew that Garret had owned a watch. It was believed that the

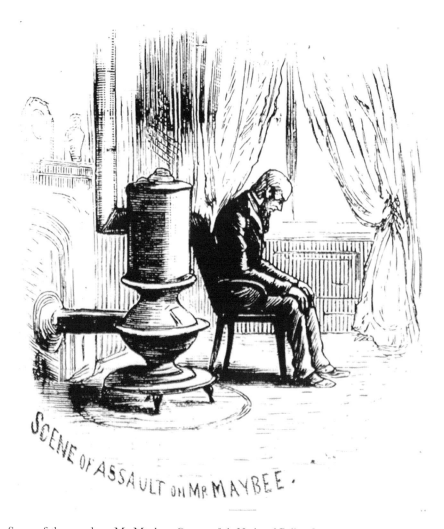

Scene of the assault on Mr. Maybee. *Courtesy of the* National Police Gazette, *December 8, 1883.*

crime may have been committed by someone who was familiar with the family and the house.

Detective James Wood from the Pinkerton Detective Agency was called in to investigate and claimed he had a suspect that more than likely was the killer. He believed it was someone close to the household, but he would not release any details. At the same time, Doyle was released from custody because his alibi was proven. The police, meanwhile, continued to arrest vagrants and bring them in for questioning.

A major snowstorm in December slowed down the investigation for weeks. On January 7, 1884, another crime was committed only three miles from Garret Maybee's farm in Oyster Bay. A prominent elderly couple named Mr. and Mrs. James Townsend were found on the floor of their kitchen, unconscious and with severe head injuries. Mrs. Townsend suffered less than her husband and was eventually able to talk to the police. Because of the ongoing developments in the investigation, the information Mrs. Townsend provided was kept from the press. However, reporters questioned neighbors and found out that Mrs. Townsend had said a man named Simon Rappalyea, an African American, had beat them. Rappalyea's wife had done laundry for the Townsend family, and Simon had come to collect money owed his wife. According to the neighbors, when Mrs. Townsend turned to get it, Rappalyea hit her on the side of the head. A watch was said to have been taken from the house.

Somewhere between the Townsend home and Rappalyea's house, the police discovered a pair of bloodstained overalls and a stonemason's hammer. Between Mrs. Townsend's account and the finding of the overalls and hammer, Rappalyea was arrested. Police then traced the found items to a man by the name of John Tappan. No stone was left unturned, so both John and his brother Edmund were brought in for questioning. Oddly, Edmund had been one of the neighbors who had responded to the Maybee house when Garret cried out, and he had also testified at the inquest. What many people did not know was that Edmund had been under surveillance for weeks and was Detective Wood's prime suspect.

During questioning, Edmund revealed that his brother John had strangled Lydia Maybee first and then waited for Annie so he could strangle her as well. He then said John entered the house, stole the money and jewelry and came out and gave Edmund ten dollars.

John Tappan knew the layout of the Maybee house because he had done work there in the past. He denied, however, having anything to do with the murders or the assault on the Townsends. Despite his denials, John and Edmund became the prime suspects in the case. As for Simon Rappalyea, there was no firm evidence against him, so he was released from custody. It is unclear why Mrs. Townsend said that Rappalyea assaulted her and her husband.

After giving his statement, Edmund Tappan apparently went into convulsions due to an illness. Many believed that it was Edmund Tappan who was the true murderer.

Another assault happened in East Meadow on the evening of January 25. This time it was a masked man demanding money from Mrs. Sealey Sprague. As the story goes, Sprague was in her kitchen when the masked man entered. She tried to get away by running past him, but he grabbed her by her hair and knocked her down. He continued to demand that she give him money, so she gave him thirty-eight dollars. According to Sprague, she could see beneath the mask that the man was of African American descent. Once the assailant left the house, Sprague ran for help. A farmer and son by the name of Petit came to the aid of Sprague, and the three went in search of Sprague's husband. When they reached the barn, they found Mr. Sprague unconscious and lying in a pool of blood. Apparently he had been hit in the head with a piece of iron used to connect train rails.

The assailant ran through the snow, leaving footprints behind him. A storekeeper in the nearby town of Westbury noticed a suspicious man enter his store to buy cheese and crackers. The police had told the storekeeper to be on alert because a criminal was on the run. The storekeeper managed to keep the man in his store while he alerted police, who quickly came and arrested him. The man was Charles H. Rugg from Oyster Bay.

Rugg initially denied the accusations, but a day later, after intensive questioning, Rugg broke down and confessed to assaulting and robbing the Spragues. He was further questioned about the Maybee murders because it was discovered that Rugg had worked on the Maybees' farm in the past. Mr. Maybee, however, did not believe that Rugg could have done the crime because during his time on the farm, he had never been inside the house, so he would not have known the layout. Maybee then convinced himself that it was Edmund Tappan's voice he heard that dreadful day.

Edmund and John Tappan still remained the primary suspects in the Townsend assaults during the time that Rugg was being questioned for the Maybee murders and the Sprague assault. During an inquest in which Edmund was asked to take the stand, he finally broke down and cried. He told the grand jury that he had made up the accusations against his brother as well as the confession. By turning his brother in, he had hoped to get the reward money, which was now up to $2,800.

Rugg was questioned again, this time about the Townsend assaults. At the same time, the watches owned by the Maybees and the Townsends were discovered at a pawnshop in New York City. The pawnbroker was brought in and identified Rugg as the man who brought the watches to the shop. In addition, a friend of Rugg's, Lance Conkling, was questioned and admitted

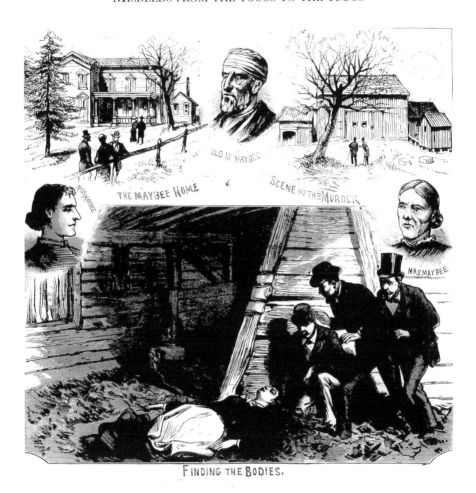

The Maybee farm and scene of murder. *Courtesy of the* National Police Gazette, *December 8, 1883.*

to being with Rugg in New York after the murders and said that Rugg had come into some money.

While Rugg was in jail awaiting his trial, he apparently became ill and started shaking violently. His jailer, John Murphy, entered the cell and brought Rugg medication that had been given to him by the doctor. When Murphy turned to leave, Rugg jumped him and then escaped from the building out a second-floor courtroom window. It wasn't until three days later that he was finally captured in a church in Woodside.

The trial began, and on April 21, 1884, it was determined by a grand jury that Charles H. Rugg was guilty of all three crimes committed on

the Maybees, Townsends and Spragues. There were a total of seven indictments handed down. Two were for first-degree murder, four for assault and robbery and one for burglary. Rugg would be hanged for his crimes.

While awaiting his execution, Rugg turned to Catholicism and to Father Maguire, who had been his spiritual adviser. Rugg professed he was converted and was ready to accept his fate. On the morning of May 15, 1885, Rugg asked if he could have one last meal before he died, which delayed the execution by several minutes. His arms were then tied to his side, a noose was placed around his neck and a black cap was placed upon his head. Stoically, he walked toward the gallows reciting the Our Father. When he reached the gallows, his legs were bound. As he began praying the Hail Mary, the trap was sprung and Rugg was lifted in the air, the noose tightening around and breaking his neck. He died instantly. In fourteen minutes, he was officially declared dead by physicians, and his body was taken down and placed in a pine coffin. A wagon took him for burial at Calvary Cemetery in Woodside. The Maybee murder was finally solved and put to rest.

CHAPTER 4

Kidnapping or Murder? The Alice Parsons Case

STONY BROOK

In 1937, an event took place that shook the normally quiet town of Stony Brook. It involved the kidnapping and possible murder of a wealthy heiress. To this day, it remains a mystery that has never been solved.

Thirty-eight-year-old Alice Parsons was married to William H. Parsons, son of a wealthy paper manufacturer. William was also related by marriage to the Pratt family, owners of the prestigious Standard Oil Company. Alice came from money as well. She was the daughter of Mr. and Mrs. Frank McDonnell from Rye, New York, and was the niece of Colonel Timothy C. Williams, the president of the Brooklyn Rapid Transit company.

She and William married at her uncle's home on November 1, 1925. It is said that it was her uncle and his wife who introduced Alice into the society scene. Alice was also listed as the receiver of her uncle's inheritance. Timothy Williams died in 1930 and left Alice $30,000 in a trust fund. The principal was to be paid to her once she turned thirty-five, which was on May 3, 1934. In 1936, Alice's aunt died, and Alice received a third of her aunt and uncle's estate called Shoreland, which had been appraised in 1930 for $220,000.

William and Alice lived in New York City, but in 1929, they moved to an eleven-acre estate in Stony Brook that they called Long Meadow Farm. Unlike other people with their means and upbringing, the Parsons lived a quiet life, and despite being listed in the "Social Register," they did not actively partake in Long Island's social circles.

William raised chickens and pigeons for market and restaurant trade and then switched to raising squabs, which were more profitable. Alice assisted

her husband and came up with what became a popular recipe for squab paste for canapes. She also sold squab pies in Stony Brook. The two could not have children because of an accident Alice had in her youth, but the couple were content with each other and running their farm and estate.

In 1931, Alice became ill and needed to hire a housekeeper to help her for a little while. It was the first time the Parsons had ever hired help. Alice's sister recommended a beautiful Russian immigrant named Anna Kuprianova. Despite Anna speaking very little English, Alice and Anna got along fabulously, and when Alice's health returned, the Parsonses decided to keep Anna on as a permanent housekeeper. Anna had a five-year-old son named Roy, who came to live with her at the Parsons home. This made William and Alice very happy, and they treated Roy like he was their own child. In fact, Anna had her son's name changed to Roy Parsons in 1936, and then she changed her own name to Anna Kuprianova-Parsons.

Everything seemed fine in the Parsons home until a year later. On the morning of June 9, 1937, William needed to make a trip into New York City. Alice drove her husband to the train station so he could make a 7:47 a.m. train, and she promised to pick him up later that evening. After dropping her husband off, Alice went home and informed her housekeeper that a couple was coming over around 11:00 a.m. and that she would be taking them over to see her aunt and uncle's estate in Huntington, which was now up for sale.

When eleven o'clock rolled around, Anna was working in the kitchen, and Alice yelled out to her that she was leaving. Alice got inside the car with the couple, and that was the last time Alice was ever seen again.

That night, William arrived home via taxi around 7:00 p.m., a little annoyed that his wife had forgotten to pick him up. Anna had been waiting for him in the house. She informed William that Alice had never come home from showing her uncle's house earlier that day. William immediately notified the police. When they arrived, the police searched the entire estate, including the Parsonses' car, which had been parked in front of the house. There were no clues or evidence anywhere. Around 1:30 a.m., one of the officers decided to shine a flashlight in the car one more time. It was then that he happened to notice a note stuck under the floorboard of the back seat. When he went into the car to retrieve it, he saw that it was a ransom note demanding $25,000 within twenty-four hours. The note had been written in pencil on tablet paper in block letters. It read: "Will Parsons, I have your wife. Bring $25,000 to the Jamaica bus terminal within the next 24 hours and my man will meet you and call you by name. Do not bring any cops. If you do, Alice will never speak to you again."

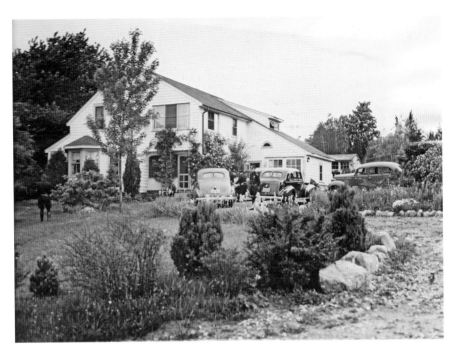

The Parsons residence in Stony Brook. Police are searching for Alice Parsons. *Historic Images.*

As soon as the ransom note was discovered, the news was reported to police in eight states through a teletype alarm. Nassau and Suffolk County police, the Brookhaven town police, the New York State police and the FBI came together to work on the case. The bulletin that went out read: "Wanted for kidnapping. An unknown man and woman in a large black sedan kidnapped Alice Parsons from Stony Brook, Long Island. Thirty-eight years old, five feet, 136 pounds, gray hair and gray eyes, ruddy complexion, wearing a blue dress with red buttons, black shoes and stockings, white beaded bag."

With the exception of Anna, there was only one other witness, a former Stony Brook postmistress named Leona Newton, who claimed she saw Mrs. Parsons around 1:00 p.m. driving in her car with another woman. How could this be if the Parsonses' car had been left at the estate all day?

William Parsons decided it was too risky to go to the bus terminal because by this point word of the kidnapping had leaked out to the press. He would not be alone. So he decided to wait in his home with Anna, Roy and Alice's two brothers in the hopes that the kidnappers would contact him. He insisted

the police leave the grounds of the estate and also the surrounding areas so that the coast would be clear for the kidnappers to return Alice.

The next day, when no word came from the kidnappers, William called on the press for help, asking them if he could make an appeal over the radio to the kidnappers. A press conference was set up, and in a heartfelt plea, William spoke directly to the kidnappers over the airwaves:

> *I want to assure the party or parties holding my wife that I am willing and anxious to follow implicitly and without question any further instructions given and that they will be treated in strictest confidence. In order that the persons holding my wife for ransom may reach me freely and at any time and without any danger of being observed or overheard, I request that all law enforcement officials and press representatives withdraw from my residence, the grounds, and vicinity, so that the coast will be entirely clear to reach me without any risk or danger of observation.*

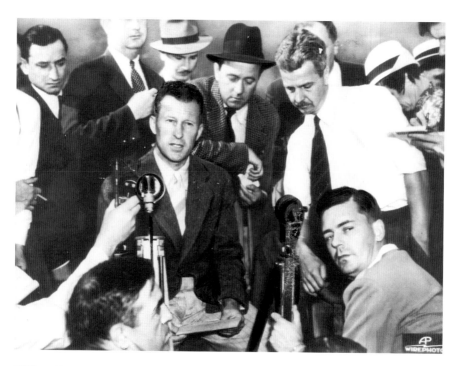

William H. Parsons appeals publicly to his wife's abductors. *Historic Images.*

Still, no word came. Five days after the disappearance of Alice Parsons, the police announced the possibility that the heiress may have been murdered. Every inch of the farm was searched again, but the police still came up with nothing. What made matters more frustrating was that the local police and the FBI did not see eye to eye on how the case should be conducted. Finally, there came a point when the local police absolutely refused to work with federal or state officers. Meanwhile, hundreds of reports from all over the country started pouring in stating that Alice Parsons had been seen in New York, Connecticut and Boston.

As the days went on, William decided to make one last plea, and this time he set a deadline for the end of the month. He continued to offer the kidnappers immunity and said that he would meet any demands they had until the end of June. At that time, if the kidnappers did not respond, the deal would be off.

The end of June came, and still there was no response. Police continued to guard the house, but as days went into weeks and months, the number of police and agents on the job was cut, and the chances of finding Alice Parsons, dead or alive, were slim.

Some people have wondered if William and Anna had anything to do with the disappearance. Despite hours and hours of questioning, they never wavered from their stories.

Twenty-two days before she disappeared, Alice Parsons had a new will drafted. In her will, she had bequeathed her husband $35,000, Anna $10,000 and Roy $15,000, which was to be held in a trust until he was thirty years old. There are conflicting stories that state that half of the remainder of the estate was set to be divided between her brothers' children, while another source stated that Alice's brothers contested the will and Anna ended up getting nothing.

Six months later, in December 1937, it is said that William moved to California, where he began proceedings to formally adopt twelve-year-old Roy. Once he did, Anna and Roy moved to California to be with him. Three years later, in 1940, William and Anna married, despite the fact that Alice was not declared legally dead until 1946. It was in that year that it was officially decided that Anna Parsons had been murdered, and the case was closed. There were never any suspects, witnesses or evidence to prove anything, and Alice's body was never found. The case of Alice Parsons will forever remain a mystery.

East Hampton Witch Trial of 1658

EAST HAMPTON

Thirty-five years before the famous Salem, Massachusetts witch trials in 1692, during which nineteen people were hanged, a witch trial took place in the small colonial town of East Hampton. The area had been settled by God-fearing Puritans who believed that all events, whether derived by man or nature, were caused by either God or Satan. According to research by historian Hugh R. King and his wife, anthropologist Loretta Orion, "the world was pregnant with supernatural meaning and signs of God's intention." The colonists feared what God would do to them next, and they believed that only a chosen few would find God's good graces. Those who went against the church were surely working with Satan, and it was said that Satan rewarded people by giving them supernatural powers to harm their neighbors, animals and property.

Women in particular were targeted. Because Eve, from the Old Testament, was the first to bite into the apple, ruining paradise for all of humankind, many believed that women were "the gateway to the devil." Since women could give birth and men could not, women were often alienated since they had a "power" that men did not. Unmarried or widowed women were also under suspicion because they often needed help and were considered a "societal inconvenience."

These reasons, coupled with women's inherent nature to gossip and stir up trouble, caused all sorts of chaos. Someone was to blame for all misfortune that took place, from the death of a child, to sickness, to poor crops or natural disasters. It was either God showing his anger or a satanic conspiracy. It was

easy to pinpoint women, especially ones who seemingly did not fit in well, for whatever reason, with society. It was believed that these women were witches, and anything bad that took place was blamed on them and the pacts they had made with the devil. The level of suspicion was enormous in the seventeenth century. So many people were accused of practicing witchcraft, which was a capital offense.

In February 1658, Elizabeth "Goody" Garlick, wife of Joshua Garlick, was accused, for a variety of reasons, of being a witch. Women of lower status during the 1600s were called "Goody," while women of higher status were called "Mrs." Goody Garlick and her husband had worked for the prominent Lion Gardiner, who founded Gardiner's Island. He ran the town of East Hampton, as well as a plantation on Gardiner's Island, where he lived in a beautiful mansion. The Garlicks lived on Gardiner's Island and worked full time for Mr. Gardiner. Eventually, the couple had enough money to buy their own home in East Hampton, and their status went from lowest to middle.

Some accounts say that several women became jealous of Elizabeth Garlick's good fortune, while others say that she was an outspoken woman who was gossipy and difficult to be with. Because she was a bit of an outcast, the local women kept their eye on Elizabeth. They were extremely suspicious of her. It is also believed that she may have been French and not English, another possible reason she was an outcast.

Goody Garlick went about her business despite the rumors that began to surface about her. One woman in particular, Goody Davis, disliked Goody Garlick because she believed the woman was envious of her. Goody Garlick had paid a compliment to Goody Davis by saying how beautiful her baby was. Instead of accepting the compliment, Goody Davis, who was much younger than Goody Garlick, believed that Garlick wanted her baby since she was past childbearing years. She believed that Goody Garlick had placed the "evil eye" on her baby. Because infant mortality was common, Davis feared for her child and felt threatened by Garlick. Garlick then asked Davis if her child was ill. Davis took it as a threat, an omen of something dreadful yet to come.

Goody Davis started spreading all sorts of rumors about Goody Garlick to the women of East Hampton, warning them about their new neighbor. The women became protective of their children, and if anything happened to a child, it was blamed on Goody Garlick.

Goody Garlick came to Goody Edward's daughter for breast milk. It is unclear why, but apparently soon thereafter, the young woman's breast milk

dried up and her child became sick. It was very common for a younger woman to accuse an older woman of trying to poison a new mother's milk. Two other women claimed that Goody Garlick came to their daughters for breast milk and the same thing happened. Five days after Goody Garlick paid the compliment to Goody Davis's baby and inquired whether the baby was sick, the woman's baby died. Goody Davis blamed it on Goody Garlick's "evil eye."

Other misfortunate events began to occur, apparently one right after another. An ox owned by Gardiner mysteriously broke its leg; a healthy pig gave birth in a strange manner and died; a black child was taken away in a suspicious manner. The list went on and on. Everything was blamed on Goody Garlick.

In February 1658, an incident occurred involving Lion Gardiner's daughter Elizabeth that led the townspeople to believe that Goody Garlick was, in fact, a witch. Elizabeth Howell was sixteen and was both a new wife and a new mother. One day, she was alone in the house when Samuel Parsons came over to visit her husband, Arthur Howell, who was not at home at the time. Elizabeth invited Samuel in and told him that she was not feeling well and that she had a terrible headache. Samuel decided he would let her be and he would come back to visit her husband later. Shortly thereafter, Arthur arrived home with his friend William Russell. Elizabeth was wrapped up near the fire and told her husband that she believed she had a fever.

Sickness was always cause for alarm among the Puritans. They believed that suffering was part of God's plan for them and that when one suffered, it meant it was time to repent. If they didn't repent, they feared death and a life of eternal damnation.

Samuel Parsons had made his way back, and the three men helped Elizabeth to her bed, where she suckled her baby. It soon occurred to her that she might make the baby sick. The baby was taken away from her, and Elizabeth began to pray. All of a sudden, Elizabeth screamed out, "A witch! A witch! Now you are coming to torture me because I spoke two or three words against you! In the morning you will come fawning." Samuel, witnessing the outbreak, said, "The lord be merciful to her. It is well if she bee not bewitch."

The three men decided they should tell Lion Gardiner of the situation, despite the fact that Gardiner was attending to his own wife who was ill. They sent Samuel to get him. When Gardiner arrived, Elizabeth's condition had worsened. She was sitting up, looking at the foot of the bed

and yelling, "A witch! A witch!" Her father asked her what she was seeing, and she informed him she saw a "black thing" at the foot of the bed. It was believed to be Goody Garlick's black cat. Elizabeth then became uncontrollable, flailing around and screaming and crying. Elizabeth's husband tried to calm her down, to no avail. Elizabeth suddenly had tremendous strength. She struggled for a few more minutes until she got to the point of exhaustion.

Elizabeth's condition did not improve, so the next day, Lion Gardiner decided he should tell his wife. Even in her own state of illness, she insisted on going over and visiting her daughter. Elizabeth started to cry when she saw her mother, Mary. She told her that she was "bewitched." Her mother was startled by this and told her that it must have been a dream. Elizabeth kept insisting that it was not a dream. When Mary Gardiner asked her who she saw, Elizabeth shouted out, "Goody Garlick! Goody Garlick! I see her at the far corner of the bed, and a black thing of hers at the corner."

Of course, by today's standard, we would say that Elizabeth more than likely was fighting an infection, the fever causing her to become delirious. But in the days of the Puritans, suspicions were high, and they truly believed that man's sin was behind everything bad that happened. Mary didn't want to hear of such things though and told her daughter not to speak of it again and to tell no one. It is believed that maybe she did not want to bring shame to the Gardiner name.

After Mary returned home, three neighbors—Goody Birdsall, Goody Edwards and Goody Simons—came by to see Elizabeth, who was now ranting even more. "She is a double-tongued woman. She pricks me with pins. Oh! She torments me," said Elizabeth. The three women questioned who she was talking about.

"Ah, Garlick," she replied, "You jeered me when I came to your house to call my husband home. You laughed and jeered me, and I went crying away. Oh, you are a pretty one. Send for Garlick and his wife. I would tear her to pieces and leave the birds to pick her bones. Did you not see her last night stand by my bedside, ready to pull me to pieces? She pricked me with pins, and she brought a black thing to the foot of my bed."

No sooner did she speak than Elizabeth clutched her throat and started choking. Goody Edwards used the handle of a knife to pry Elizabeth's mouth open and found nothing blocking her throat. Believing it could be witchcraft, the women concocted a remedy of oil and sugar and made Elizabeth drink it. Within a few minutes, Elizabeth started coughing, and a pin fell from her mouth. Goody Simons picked it up.

Pins were a sure sign of witchcraft; there are several on display at museums in Salem, Massachusetts. Could Goody Edwards or Goody Simons somehow have placed the pin in Elizabeth's mouth to set up Goody Garlick?

Goody Edwards and Goody Birdsall returned home, and Goody Simons stayed around Elizabeth's bed along with Elizabeth's husband, Arthur; William Russell; and a female slave named Boose. A little after midnight, the men and Boose heard a strange scratching sound. Elizabeth and Goody Simons had fallen asleep. They searched the room, but no one could find where the sound was coming from. Other strange noises started coming from the inside of the fireplace.

The next day, the pastor, Thomas James, was brought in to pray for Elizabeth's soul. Things were not looking good. Elizabeth's fever continued, and she let out one last cry: "Garlick...double-tongued...ugly thing...pins..." She then called out for her mother, who was not there. Finally, Elizabeth's torment came to an end, as she peacefully slipped away into death.

After the burial of Elizabeth Gardiner Howell, Goody Garlick was accused of practicing witchcraft. The magistrates gathered and an inquest began to determine whether Goody Garlick had killed Elizabeth through witchcraft. This was new territory for the magistrates, who were accustomed to handling more rational issues. With the exception of Lion Gardiner, all witnesses to Elizabeth's torment and death came forward to testify.

A lawsuit was then filed by Joshua Garlick, who accused Goody Davis of slandering his wife. Goody Davis then changed her story, saying that Goody Garlick had brought her many things and had been very kind to her. One of the men who had testified claimed that Goody Davis had killed her own baby by selling her breast milk for wampum, thus starving her child. The

An example of a witch trial taking place.

women testifying in the court continued to blame Goody Garlick for all the tragedies and upheaval that had been occurring in the town. Oddly enough, Goody Davis died two weeks after the defamation charges came against her. Her cause of death is unknown.

The magistrates were at a complete loss on how to handle the case. They decided to contact a more experienced court in Connecticut that knew more about cases of capital crimes and witchcraft. The Connecticut court then took over the case. It had tried at least eight cases of witchcraft since 1647.

The case was heard by Governor John Winthrop Jr. on May 5, 1658. It was his first witchcraft trial. Twelve men served on the jury, and the trial lasted for three weeks. It was very challenging to determine whether witchcraft or natural causes were the cause of death. Several criteria had to be met to determine witchcraft. The Connecticut court could not come up with sufficient evidence to convict Goody Garlick of witchcraft as it related to Elizabeth Howell's death.

There were three possible verdicts in the 1600s: guilty, not guilty and innocent. The court did not believe that Goody Garlick was innocent, but it did believe she was not guilty of the crime laid before her. In return, Joshua Garlick had to post a large bond and assure his wife's future good behavior. Judge Winthrop sent Goody Garlick and her husband back to East Hampton with a warning to everyone to try to get along.

Some believe that it was Lion Gardiner who helped get Goody Garlick off. He knew the judge and was skeptical of maleficium. It is also possible that he wanted respect for the Gardiner name and didn't want it associated with witchcraft. However, all mention of Lion Gardiner and the trial has either been lost or destroyed.

Goody Garlick escaped the death penalty and resumed her life in East Hampton. It is believed that the case of Goody Garlick was the only witchcraft trial that ever took place in East Hampton.

The Woodward Murder

OYSTER BAY

The old Woodward estate in Oyster Bay Cove is full of tales of murder and intrigue. The house was built in 1927 for Mrs. E.F. McCann, a daughter of F.W. Woolworth. It is believed the McCanns lived in the house until the 1940s, at which time it was sold to William Woodward Jr., a millionaire sportsman. Woodward's favorite sport was horse racing, and he and his wife, Ann, owned the famed racehorse Nashua.

Woodward was prominent on the social scene. He was thirty-five and handsome, and his mother, Elsie Ogden Cryder Woodward, was regarded as one of the reigning socialites in New York. His wife, Ann, was born in Kansas but had quickly worked her way up the social ladder. She was a beautiful blond, a former actress and model. The two made a stunning pair.

They lived in Oyster Bay Cove on a forty-three-acre estate that was also known as "The Playhouse" because of the huge, blue glass–topped building on the grounds. It is said there were only a few playhouses built on the North Shore, and they were used for recreation, parties and overnight guests. These enormous buildings, usually separate from the main house, would often contain a tennis court, steam rooms, a pool, guests' quarters and areas for entertaining. The Woodwards' playhouse was quite striking, and so was their house, which was filled with Rembrandts, a giant music hall, a marble fireplace, rare tapestries, stained glass and many other unique features, including a massive pipe organ that could be heard for miles when it was played. The cobblestones used to create the driveway had been shipped over from Fotheringay Castle in Scotland and were the

A view of the Woodward estate.
Photo by Kerriann Flanagan Brosky.

same stones on which Mary Queen of Scots stood just before she was beheaded back in the sixteenth century.

The Woodwards' estate and lifestyle were the envy of people in their day. However, on the evening of October 30, 1955, everything changed. The Woodwards had been attending a party in honor of the Duchess of Windsor at the Locust Valley estate of Edith Baker, the widow of a wealthy banker. During the party, there had been talk about recent break-ins and burglaries in several North Shore mansions. The Woodwards mentioned that a prowler had broken into their pool house just the night before, and because of this, they had decided to sleep in separate bedrooms that night. Their rooms were located across from each other, on the first floor. Both of them had weapons beside their beds; William had a revolver, while Ann had a double-barrel twelve-gauge shotgun.

There were two conflicting stories about the behavior of the Woodwards that evening. Some said they seemed fine and were enjoying themselves; William Woodward had only a few drinks, while Ann drank nothing. They left the Baker estate for home at 1:00 a.m. However, others said that some guests had overheard the Woodwards arguing at the party shortly before leaving at midnight. Exactly what occurred at the party is not known, therefore.

Upon arriving home, the Woodwards went off to their separate bedrooms. Around 3:00 a.m., according to Ann, she awoke to the sound of her dog barking and, upon rising, thought she heard the sound of a burglar entering the house. She turned on a nightlight, grabbed her shotgun and headed out of the bedroom. As soon as she opened the door, she saw a figure standing in the darkness in the doorway of her husband's room. Without saying a word, she fired two shots across the hallway. As the body fell to the floor, she realized it was not that of a burglar but instead was her husband. Horrified, she ran to him immediately and then called the police.

When the officers came to investigate, they found William Woodward nude, lying dead, near the doorway of his room. One shotgun blast had nearly taken off his head, while the other had struck the bedroom door. During the shooting, the Woodwards' children—two boys, ages eleven and seven—had somehow remained asleep. When the police arrived, the boys were quickly taken to their paternal grandparents' home, while Ann Woodward was whisked off to the Doctors Hospital in Manhattan.

Apparently, Ann had mistaken her husband for a burglar. She claimed that her husband must have also heard the dog barking and the noise of someone entering and came out of his bedroom. He did not take his gun, however, which was very odd. The police found the revolver in a table near his bed. If he was coming out to confront an intruder, why did he not have his gun, and where were his clothes?

While at the hospital, Ann said she was too distraught to answer any further questions. Rumors started to fly in the elite social circle as to how this could have happened and if it indeed was an accident. Many believed it was not. It was discovered that Ann Woodward had hired a private detective on and off for several years. His job was to see if her husband was cheating on her. The detective came forward and turned over to the police at least a dozen women's names that Mrs. Woodward had given him. All were suspected of having an affair with her husband.

Another theory was that Ann had never been truly accepted by her husband's family and that they had originally opposed the marriage. A private detective was hired by William Woodward's family to do their own investigation into the shooting. They also spoke to the family lawyer and asked how much money Ann would receive from her husband's fortune. The lawyer estimated it to be in the millions.

Did Ann catch her husband having an affair in their own home? Did the woman escape after the shooting? Or did Ann kill her husband for past affairs? Was she trying to inherit his money? Then again, perhaps it was an accident, and she had come out with the gun to defend her husband and her family.

Ann remained in the hospital for several days and missed her husband's funeral. She was again questioned by detectives, but she held fast to her story. She was to appear before a grand jury, which would decide her fate.

Meanwhile, police detectives found a man named Paul Wirths, whom they had been seeking for some time. They knew of his crimes but had not yet caught him. Then they discovered that Wirths had been arrested in Suffolk County, and he was turned over to the Nassau detectives for questioning in the Woodward shooting.

Above: Mrs. Woodward en route to court in Nassau County. She is pictured here with her lawyer, Maurry I. Gurfein. *Historical Images.*

Right: Mrs. Woodward sobbing on her way to testify before the Nassau County Grand Jury. *Historical Images.*

Wirths claimed that he entered the Woodward house that night, and when he heard the shots, he immediately fled and hid in a barn. The police were unsure of his story at the time, but Wirths kept insisting. He told police that he had broken a tree limb while climbing up to a window of the mansion. Once inside, he said he hid in a closet that contained a safe. On further investigation, the detectives surmised that his story was true. They found the broken tree limb, and the closet Wirths described did, in fact, contain a safe.

Three weeks after the shooting, Ann Woodward appeared before the grand jury, testifying for only twenty-five minutes. The case was open and shut. The grand jury cleared her of any charges and deemed the shooting an accident.

Many claimed that she was released because of her status and because Wirths's story, which seemed accurate, proved he was in the house. But over the years, people have been questioning her account of the event. It became a theme for two separate novels. The first was Dominick Dunne's *The Two Mrs. Grenvilles*, which was made into a film, and the second was *Answered Prayers* by Truman Capote.

In 1975, Ann was given an advance copy of a magazine excerpt that discussed Capote's book. In his version of the story, he found the character that was based on Ann Woodward guilty of murder. Friends of Mrs. Woodward said that after reading this account, she became deeply upset and withdrawn. She killed herself in her Park Avenue home that same year.

Did Mrs. Woodward intend to kill her husband or was it in fact an accident? The mystery remains.

The Hawkins Murder

ISLIP

A prominent family by the name of Hawkins lived in the village of Islip in the late 1800s. Brothers Franklin and J. Clarence Hawkins were very well known in the coal and lumber business, where they became quite successful. They, along with their wives, came from the oldest families who had originally settled in Islip. Franklin Hawkins died around 1880 and left behind his wife, Cynthiana Hawkins, and three children: Asbury, age fourteen; Grace, age eight; and Franklin, age three. Cynthiana inherited everything from her husband's estate, including the property, which was worth $30,000 at the time.

While his father was alive, Asbury had caused his parents a great deal of anxiety because of his relationships with the servant girls. In those days, a well-to-do family like the Hawkinses could not possibly have their child associate with those who they considered to be from a lower class. They tried to keep Asbury away from the girls.

Asbury continued to spend time with the servant girls even after his father died. Asbury and Cynthiana Hawkins would often argue about it, Cynthiana stating that Asbury needed to associate with girls of his own status. At the same time, Asbury apparently started drinking and hanging out with the wrong crowd. Cynthiana would lecture Asbury on his behavior, to no avail. Unable to get along with his mother, Asbury left Islip and moved in with his uncle in Bay Shore. His uncle owned a grocery store, and he hired Asbury as a clerk and paid him ten dollars a week. While working there, Asbury met Hattie Schreck, a beautiful young woman who worked at Perry Wick's

ice cream shop nearby. Hattie quickly won Asbury's affection, and the two started seeing each other. Hattie eventually left the ice cream shop and started working as a servant in the home of Dr. Mowbray. Shortly thereafter, Asbury promised to marry Hattie one day. Mrs. Hawkins found out about Asbury's obsession with the servant girl, and she did everything she could to try to end the relationship. The more Mrs. Hawkins fought him on it, the more determined Asbury was to marry the girl.

Hattie did not work for Dr. Mowbray for long, and soon she moved from Bay Shore to Northport, which was about fifteen miles away. Every Sunday, Asbury would hire a horse and buggy from a livery in Bay Shore and drive out to see her. He would first stop in Islip at his mother's house, and then he would head to Northport to spend the day with Hattie. Asbury still tried, on numerous occasions, to talk to his mother about the marriage, but she would hear nothing of it. She refused to give her consent.

On the evening of October 1, 1887, Asbury, now twenty-two, told his uncle that he was going to meet some friends in Babylon who were arriving by train. He hired a horse and buggy in Bay Shore, and instead of going to the train station, he drove to his mother's house in Islip. He arrived around 9:30 p.m. to find his mother sitting in the parlor alone. His brother was out, and his sister had gone to bed. He told his mother that he would take her to see her sister, Mrs. Edgar Smith, who was gravely ill. Mrs. Hawkins quickly collected her things, and they headed out in the horse and buggy.

As they traveled along, Asbury once again brought up the subject of him marrying Hattie Schreck, and as always, Mrs. Hawkins adamantly denied consent. At that very moment, Asbury took a revolver out of his pocket, and before Mrs. Hawkins knew what was happening, he shot her in the forehead. The horse, unaffected by the sound of the gunshot, continued walking along toward Mrs. Smith's house. Asbury then turned the horse around in the main road and headed toward an old road that led to Brentwood, a town about four miles away. About halfway there, when he got near the Oakwood Cemetery, he rolled his mother out of the buggy and placed her on the ground, covering her bloodied body in leaves. A pool of blood lay on the floor of the buggy. It wasn't until then that Asbury realized what he had done. He turned the horse and buggy around and headed back toward Bay Shore. As he drove, he desperately tried to mop up the blood with a lap blanket. He was too nervous to stop and try to give the buggy a proper cleaning.

As the story goes, Asbury arrived at the livery stable at 11:00 p.m. He told the liveryman, Mr. Snedeker, that he would like to have the same buggy in

The scene of the crime. Mrs. Hawkins's body is underneath the leaves. *Sketch by Joan Harrison.*

the morning for his trip to Northport. Snedeker told him he would make sure the buggy got washed for him, but Asbury quickly replied no. He explained to the man that it was late, and he'd have it properly washed and greased when he arrived in Northport. When Snedeker turned away, Asbury took the bloodied lap blanket, rolled it in a ball and stuffed it under the seat of an old carriage before making his way back to his uncle's house.

The next morning, he arrived at the livery at 6:00 a.m., looking a bit disheveled and nervous. Snedeker assumed it was because he had been drinking the night before. He gave him the same buggy but a different horse, and soon Asbury was on his way to Northport. Along the way, he stopped at Wheeler's Hotel, where he asked for water and cleaning brushes. He then carefully cleaned both the inside and outside of the buggy, including the cushions and curtains. Once he felt the buggy was cleaned well enough, instead of going to see Hattie, he turned around and drove to Babylon, where he stopped for dinner. By 4:30 p.m., he had arrived back at the livery stable in Bay Shore where he returned the rig.

What Asbury did not know was that his mother's body had been found that same day. Joseph Preston, the keeper of the Oakwood Cemetery, was driving with his friend William Gooder to Brentwood around nine o'clock in the morning when they made the grisly discovery. Through the leaves, they saw what looked like a red shawl. Upon closer examination, they found the body of Mrs. Hawkins lying facedown. As quickly as they could, they made their way to Bay Shore, where they got hold of Justice of the Peace Seth R. Platt. They told him what they had discovered, and Platt telegraphed Coroner Edwards from Patchogue.

Before long, word got out, and a whole slew of people went to where the dead woman's body lay. Many recognized her as Cynthiana Hawkins. The tracks made by the wagon wheels, as well as the imprints of the horse's shoes, were clearly visible. One of the men present, a blacksmith by the name of George Thorne, looked at the imprints left behind from the horse and believed that the horse may have been shod by blacksmith Burr of Bay Shore. There was an imprint of a bar shoe, not typically used, on the horse's left foot, while a broken shoe imprint appeared on the left hind foot. Blacksmith Burr was questioned, and he said that he did shoe a horse for Snedeker at the livery that matched that description. When they spoke to Snedeker, he said that the horse taken out the night before did indeed have a bar shoe and a broken shoe, and that it was Asbury Hawkins who had taken him out. Another horse shoer, Michael Whalen, removed the shoes from the horse's hooves and brought them over to where the body was found. When the shoes were placed in the imprints, they matched exactly.

The body of Mrs. Hawkins was examined by the coroner. Cuts and bruises appeared on the woman's head, and it was determined that the murderer more than likely beat the woman after he shot her to silence her death screams.

The coroner, a man by the name of Mr. Edwards, had further questions for Snedeker. Snedeker recalled seeing Asbury throw something into the nearby pond that Saturday night. Since it was dark, he could not see what the object was. The town superintendent, Arthur Downing, decided to search the pond. When he did, he discovered a pistol that clearly had been fired. One of the cartridges had exploded. The livery stable was also searched, and bloodstains were found on the barn floor in the place where the carriage had been left, as well as in the buggy.

Meanwhile, while all of this was going on, Grace Hawkins, who was now sixteen, woke up and could not find her mother. She noticed that

The historic Oakwood Cemetery as it appears today. *Photo by Kerriann Flanagan Brosky.*

her mother's bed had never been slept in. She went across the street to her uncle's house to see if her mother had gone there. When she found out she hadn't been there, Grace became quite alarmed. Along with her uncle, P.J. Hawkins, and Mrs. Hawkins's brother Jesse Clock, they set out to Mrs. Smith's house to see if Mrs. Hawkins was there. Along the way, they ran into Mr. Preston from the Oakwood Cemetery, who informed them of Mrs. Hawkins's death. News spread quickly, and people came from all over Islip to search for the murderer.

All evidence pointed to Asbury Hawkins. A search of Asbury's uncle's house revealed a pile of bloodstained clothing hidden in a trunk. Several people, including Supervisor Robbins and Coroner Edwards, waited in Northport to see if Asbury would show up at the livery stable. A short while later he did, and it seemed like he had been drinking. Not divulging news of the murder, Supervisor Robbins simply asked him of his whereabouts the night before. Asbury told him that he had gone to Babylon. When asked about the blood that was found, Asbury said that he had gotten a very bad bloody nose on the way. Not believing him, Coroner Edwards stepped forward and told Asbury that he was under arrest, despite his claim that he didn't know anything about the murder.

Asbury was taken away at the coroner's request, to a restaurant where he could be guarded. On the way to the restaurant, they passed Mrs. Hawkins's house, where her murdered body now lay. Asbury showed no remorse or emotion when passing by the house. Instead, he began to whistle and sing the disturbing song "Climbing Up the Golden Stairs." Once at the restaurant, an angry mob formed and screamed out that Asbury should be lynched.

Town hall was opened that afternoon, and the constable brought Asbury in, along with his counsel, Timothy Griffin. The preliminary hearing was waived by Griffin, and Asbury was escorted to the Riverhead Jail, where he would await his trial. Rumors started circulating that Asbury made a full

confession to his uncle Nathaniel Oakley Cook, but the confession could not be obtained from him.

A jury selection began, and the trial for Asbury Hawkins began a few weeks later on December 6, 1887. The defense claimed insanity and absence of premeditation. The next day, the jury deliberated for three hours. On December 7, 1887, Asbury was found guilty of matricide and was sentenced to be hanged.

Almost a year later, on December 15, 1888, Asbury Hawkins was executed by way of hanging. He was supposedly buried in Oakwood Cemetery in Islip, not far from where he had murdered his mother. Hattie Schreck was seen crying by his grave.

Starr Faithfull: Drowning, Murder or Suicide?

LONG BEACH

It was early June 1931, and summer on Long Island was about to begin. Since the 1920s, Long Beach, a barrier island off the south shore of Long Island, had been becoming a fashionable summer beach community. Mansions and hotels were built, as were bungalows and boardwalks, and there were always a lot of fun activities to do.

On the morning of June 8, Daniel Moriarty took his daily walk along the sandy beaches to do some beachcombing. To his astonishment, he found more than shells and rocks. He discovered the dead body of a beautiful young woman washed up along the shoreline. She was wearing silk stockings and an expensive black and white paisley dress from Lord & Taylor. The woman was Starr Faithfull.

Starr Faithfull was a wild, self-made socialite who lived during the jazz age of F. Scott Fitzgerald, Prohibition and parties. She was often seen wearing expensive flapper outfits and frequented speakeasies and nightclubs. She did not come from money, nor did she have a job. Who paid for her glamorous clothing, no one knows, just as no one knows how she ultimately ended up dead on a beach. To this day, it remains a mystery.

The story of Starr Faithfull is a sad one. She came from a very dysfunctional family and lived a strange and tormented life. She was born Starr Wyman in Evanston, Illinois, on January 26, 1906, to Helen Pierce and Frank Wyman. Helen came from a line of old New England families, many of whom came from wealth. Her side of the family, however, was impoverished. Frank was an investment broker in Chicago who didn't make much money. What little he did, he squandered away.

Shortly after Starr was born, her family moved to New Jersey. Not long after, her younger sister, Elizabeth, who became known as "Tucker," was born. Starr was a happy and bright child who, at age eleven, attended Rogers Hall Academy in Lowell, Massachusetts, which was paid for by her rich aunts and cousins. One of these relatives, Andrew J. Peters, a forty-five-year-old cousin of Starr's mother, took an interest in the child. Every summer, Starr would stay with his family at their summer home in North Haven, Maine. Peters was a prominent political figure in Boston. He had been a congressman and assistant treasury secretary in charge of customs to President Woodrow Wilson before becoming the mayor of Boston in 1917.

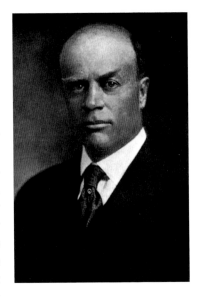

A portrait of Andrew J. Peters.

Helen and Frank were having marital problems around this time, and Helen believed that Peters was acting as a father figure to young Starr. What she didn't know was that her daughter, from age eleven on, was being given ether and being sexually abused and molested by her cousin. For many years, Peters would take Starr on long car drives and stay with her in hotels. Starr's parents could never imagine the horrible things that were happening to their daughter.

During her teenage years, Starr began acting strangely. She was no longer the happy little girl of her childhood. She became sullen and withdrawn, and despite her beauty, she dressed in boys' clothes as a means of hiding her femininity. What no one knew was that she was trying to make herself unattractive in an effort to keep Peters away. Her education was affected as well, because Starr didn't finish school. She dropped out two months before graduation. After leaving Rogers Hall, life changed, and she got involved with the depravity of the jazz age. You would think her parents would have seen the signs that something was terribly wrong and questioned their child, but being wrapped up in their own problems, they did not.

Eventually, Starr's mother divorced her husband and got remarried to the eccentric Stanley Faithfull from Brookline, Massachusetts. Stanley's first wife, a governess, had died. Stanley was first a chemist who made little money, and then he became a salesman for a pneumatic mattress company.

Helen had struggled financially with her first husband, and unfortunately, she would continue to struggle financially with her second.

As for Starr and Tucker, they decided to take Stanley's last name as their own because the name seemed more fashionable to them. They moved to Greenwich Village with Stanley and their mother, and lived only a few doors down from New York City mayor Jimmy Walker. Neither girl had much use for Stanley, and Starr often complained about him and the rest of her family in her diaries.

By the time she turned eighteen in 1924, Starr had confessed to her mother and Stanley what Peters had been doing to her for eight years. Some conflicting reports claim that Starr was actually twenty when she confessed to them, the year being 1926. In any event, sadly enough, the Faithfulls took this as an opportunity to blackmail Peters. After all, they did need the money.

Peters, although he was no longer mayor at this point, was seeking the Democratic nomination for governor (which he did not get). The last thing he needed was to have news of his inappropriate behavior with a young relative come out. So to keep them quiet, he wrote a check to the Faithfulls for $20,000. Some of the money was spent on treatment for Starr, who was diagnosed as "emotionally unbalanced." Despite the effort, she would never again be the same.

Starr at this point was well on her way to becoming morally corrupt. She drank heavily and was known to take barbiturates and inhalants, which Peters had gotten her hooked on. Her behavior was loose and erratic, and she was known to hook up with men. A diary that surfaced after her death revealed her to have had sexual liaisons with nineteen men including Andrew J. Peters, who she referred to in her book as "AJP."

The atrocities that took place for so many years destroyed Starr's life. At age nineteen, she spent nine days in a mental hospital in Boston. On another occasion, she was committed to Bellevue Hospital in New York after she was found beaten, drunk and naked in a hotel room.

Despite her issues, she somehow managed to take a nine-month cruise to the Mediterranean in July 1926. Where she got the money to do this, no one knows. She was actually known to sneak her way onto cruise ships, and sometimes she would get caught. Apparently she took at least eight ocean voyages and made her way to London on three separate occasions. On one trip, she overdosed on sleeping pills and almost died.

During her travels, Starr especially liked the bon voyage parties and would flirt with the ship's officers. She fell in love with a Cunard ship surgeon, Dr. George Jameson Carr, after he pumped her stomach after

a night of heavy drinking. She became obsessed with him, writing him letters, but he did not return her affections. In the letters, she would reveal how much she hated her life, how depressed she was and how she wanted to commit suicide. In one letter, she wrote, "To end my worthless, disorderly bore of an existence before I ruin anyone else's life as well. I certainly have made a sordid futureless mess of it all. I take dope to forget and drink to try and like people, but it is of no use. Everything is anti-climax to me now. I want oblivion."

On May 29, 1931, Starr, who was in a drunken state, was forcibly removed from the ship *Franconia*. As she was led to a tugboat that would take her back to shore, she began screaming, "Kill me! Throw me overboard!"

The last time Starr Faithfull was seen was a few days later, on June 5, 1931. Apparently, she had made her way onto another ship, the Cunard liner *Carmania*, where she had lunch and tea with a man by the name of Charles Young Roberts, the ship's surgeon. She had known Roberts for about a year, but it is unknown if she ever had relations with him. She talked to Roberts about plans she was making to travel to Europe. Then she told him of the love she had for Carr and how miserable she was. She wasn't drinking, but to Roberts, she did seem to be on something. She told Roberts that she was planning on attending a party on another ship later that evening, the *Ile de France*. Starr left the *Carmania* shortly after 10:00 p.m., and Roberts got her a taxi, giving her a dollar for the fare. He believed she was headed to the *Ile de France*.

Stanley Faithfull, meanwhile, went to the police and reported his stepdaughter missing, stating she went out to get her hair done on June 5 and never returned home. A few days later, on June 8, Faithfull returned to the police station to say that Starr was still missing. They had no information at that point for him.

That same afternoon, Faithfull came across a short article in the newspaper that spoke about a female body being washed ashore on Long Beach. He had a hunch it just might be his stepdaughter. He contacted the police yet again, who directed him to the Nassau County Police Headquarters. Upon his arrival, the police showed him the dress and stockings that had been removed from the corpse. Faithfull identified them as Starr's. Faithfull was told the woman had died from drowning and that it was either an accident or a suicide. Faithfull was convinced, however, that it was murder.

Despite telling the police not to contact the press, upon arriving home Faithfull called a press conference where he told lies to reporters, saying that his stepdaughter was "a quiet, literary, home-loving girl

with no serious boyfriends and no bad habits." He claimed "she was a light-hearted, happy, tranquil-minded girl" and that she had no reason to commit suicide. He continued to say that she was murdered, an accusation the police took seriously.

The first autopsy was performed by Dr. Otto Schulz, who believed that Starr "had been drowned in shallow water, and that she had been roughly handled." He surmised that two men may have held her head under water until she died. He believed she had been dead for about forty-eight hours when she was found on the beach. He claimed there were no drugs or alcohol found in her system.

A second, more thorough autopsy was performed by an official toxicologist from New York University, Dr. Alexander Oscar Gettler. According to his report, analysis of her organs showed that she had about twelve grains of the powerful barbiturate Veronol in her body. This was a large amount. Two grains would make a person sleep. Twelve grains would make a person unconscious for a long time or could even cause death. There were also bruises and abrasions found on the body, which indicated she may have been in a violent struggle before she died. A good amount of sand and seawater was found in Starr's lungs, and a toxicology report stated there had not been alcohol in her system for thirty-six hours. It was also determined that she had eaten a large meal of meat, potatoes and fruit shortly before she died.

An inquest took place, and Assistant District Attorney Martin Littleton asked Stanley Faithfull if he had any idea who could have killed Starr. The scandal that had been kept secret for so long was now about to be revealed.

Faithfull explained to Littleton about Peters. Oddly enough, a few days before Starr's death, Stanley had gone to Peters's office in Boston to hit him up for more money. Stanley Faithfull was broke. At the same time, Peters's attorney received an anonymous phone call from a man saying that Peters had paid "a large sum of money to a young woman named Starr Faithfull, in settlement of certain charges she had made against him."

Stanley Faithfull presented the DA with a copy of the $20,000 check and the written agreement he and Peters made in 1927 holding Peters harmless for molesting Starr.

Reporters got wind of the story, and the scandal came to a head. Peters was questioned by the DA's office and denied the charges. He failed to explain why the Faithfulls had been blackmailing him. A few days later, Peters had a nervous breakdown in his office.

Meanwhile, two detectives "mysteriously uncovered" a thirty-eight-page diary belonging to Starr "somewhere in Manhattan." This was interesting to note, because Stanley Faithfull claimed the diary had been destroyed. Another diary surfaced, and whatever information was in it led the authorities to believe that on the night of June 5, Starr did in fact make her way onto the *Ile de France*, where she may have been pushed overboard for reasons unknown.

While the court proceedings were still going on, the body of Starr Faithfull was sent to a crematory in Rockville Centre. In a strange twist of events, as a small group of family members assembled for the funeral, District Attorney Elvin N. Edwards halted the cremation process until the next day, while more statements from witnesses were gathered.

Two more witnesses came forward who claimed they were the last people to see Starr Faithfull alive. One was a taxicab driver who drove Starr; however, it was not the cab that Dr. Roberts had hailed for her. This cab driver, Si Bockman, said he picked the girl up at the Chanin Building on Forty-Second Street on the night in question. He said, "She was smartly dressed, but obviously under the influence of liquor." Apparently she had entered the lobby of the building with an unknown older woman, whom he described as being "a character." Traffic Patrolman Bellochi, the second witness, claimed he helped Starr and the other woman into the cab. The older woman kept telling the driver and the patrolman that the girl was sick and that someone needed to take care of her. Patrolman Bellochi had suggested calling an ambulance, but Starr had gone berserk with the idea of going to a hospital.

It is unclear where Starr went from there. Did the taxi driver bring her somewhere? Did the patrolman send her someplace else? A lot of information surrounding the case appears to be missing or conflicting with other reports from the trial, which adds to the mystery surrounding the case.

The questions remain. Where was Starr Faithful on the night of June 5? Who was she with, and was it murder or suicide? Of course Peters was the first suspect; however, detectives who were questioned believe that although Peters had a very inappropriate relationship with Starr, it "in no way indicates that he was knowingly responsible for her premature death." There was no evidence brought against him. Other people believed it was Stanley who killed her, although no evidence or motive came forward to prove that either.

In 1996, crime historian Jonathon Goodman wrote a book called *The Passing of Starr Faithfull*. He came up with his own theory as to how Starr died. According to his research, there was a flaw in the case. It was noted

A portrait of Starr Faithfull. *Courtesy of the Nassau County Parks, Recreation and Museums Photo Archive Center.*

that it was 10:30 p.m. when the police officer saw Starr get into the cab. The *Ile de France* left the dock exactly at 10:00 p.m. Logistically, Goodman knew that Starr could not have been on the ship that night, or on any other liner for that matter, after she left the *Carmania*. So he did not believe she was pushed overboard on any ocean liner. Instead, according to his research, three different police informants told investigators that

Boston gangsters found out about the situation Peters was in and decided to blackmail Peters for $30,000. A rival gang then supposedly stole the money and set out to get more information on Peters from Starr. They could hold this new information against Peters to get even more money from him. Continuing Goodman's theory, a gangster by the name of Vannie Higgins had orders to have Starr kidnapped and brought to an undisclosed location, where she was given a meal and then drugs. She was then questioned, and perhaps Higgins was not satisfied with her answers and had the girl beaten. Wanting it to appear as if she had a boating accident, she was taken out to sea in a speedboat, where she was dumped off the shore of Long Beach. This theory is possible but cannot be proven.

Since Starr was known to be promiscuous, there is always the chance that Starr met a strange man who, as had happened the year before, beat her. To cover up his deed and prevent Starr from going to the police, perhaps he drowned her and ran off.

It is still quite possible that Starr committed suicide, but where did the cuts and bruises come from? In one letter to Carr, Starr wrote, "My worthless, disorderly bore of an existence....I certainly have made a sordid, futureless mess of it all. I am dead, dead sick of it....Life is HORRIBLE....I have, strangely, enough, more of a feeling of peace or whatever you call it now that I know it will soon be over. The half hour before I die will, I imagine, be quite blissful."

The last letter to Carr was written the day before Starr disappeared and gave more specifics about the notion of suicide:

> *It's all up with me now. This is something I am GOING to put through. The only thing that bothers me about it—the only thing I dread—is being outwitted and prevented from doing this, which is the only possible thing for me to do. If one wants to get away with murder one has to jolly well keep one's wits about one. It's the same way with suicide. If I don't watch out I will wake up in a psychopathic ward, but I intend to watch out and accomplish my end this time.*

There had been many other occasions when Starr would speak of or write about suicide, so she was not taken seriously by Carr. He believed it was all part of the drama.

We will never fully understand what happened to Starr Faithfull. Sadly enough, when Starr was finally cremated, her ashes were never claimed by

her family. Apparently they had failed to pay the bill for the cremation. It is unknown what the funeral home did with her ashes.

In 1935, author John O'Hara wrote a novel called *Butterfield 8*, which told the story of Starr Faithfull. It was eventually made into an Academy Award–winning movie starring Elizabeth Taylor.

To this day, beachgoers, surfers and joggers out in an early morning mist have claimed to see the ghost of Starr Faithfull standing on the edge of a jetty on Monroe Boulevard in Long Beach dressed in her flapper dress, still looking for peace.

The 1842 Alexander Smith Murder

GREENLAWN

One of the oldest houses in Greenlawn, known as the Smith-Gardiner House, sits on the northeast corner of Little Plains Road and Park Avenue. It was owned and lived in by Herbert Gardiner, the last family member to live there. Having no relatives to speak of, upon his death in 2002, the house was bequeathed to the Greenlawn-Centerport Historical Association. Herbert and his twin brother, Harold, were born in the house in 1902. They lived there with their two sisters, Alice and Zella, until their deaths. Throughout the time Herbert lived there, which was his whole life, the house was virtually untouched—a time machine—bringing those who entered back decades.

Today, the house, which is in the National Register of Historic Places, serves as a museum and working farm where many historical society activities and events take place. For years, the Greenlawn-Centerport Historical Association has painstakingly restored the house and made it into a showpiece in the community.

What many people don't know is that a terrible double murder took place in the house in 1842.

It is believed that the house was built by Henry Smith sometime during the mid-1700s. It is a three-bay, two-and-a-half-story vernacular Italianate structure with some Colonial features. To this day, there are several outbuildings on the property, including a large barn, shed, chicken coop, privy and family cemetery.

The Smith-Gardiner House in Greenlawn as it appears today. *Photo by Kerriann Flanagan Brosky.*

Smith was married three times and had two sons by his second wife. One son, Alexander Smith, was born in 1773 and lived in the house his father built through both his first and second marriages. He was a well-known and respected member of the community. Alexander's first marriage was to Elizabeth Chichester, and they had one daughter together named Fannie. It was with his second wife, Rebecca Lefferts, that their lives ended in terrible tragedy on November 13, 1842.

A German farmhand by the name of Antoine Keisler had been employed at the Smith farm for two weeks. Greenlawn at that time was known as Old Fields. Keisler, knowing that Alexander Smith was a wealthy farmer, set out to rob him one Sunday evening. When Keisler entered the house, he saw both Alexander and Rebecca there. He then brutally murdered them with a mason's hammer and possibly an axe as well. It was believed it was his intention to search for money and then burn the house down to destroy the evidence. However, he became startled by the sound of passing wagons. He gave up his search for the money and then left a canister of gunpowder on the steps of the front door.

The next morning, another farmhand by the name of George Weeks reported to work at the Smith farm. Weeks lived a quarter of a mile away,

and his usual routine was to stop at the Smith farmhouse before heading out into the fields. On the morning of November 14, he noticed that a window on the east side of the house was shattered. As he peered in the broken window of the front parlor, he made a gruesome discovery. Mr. and Mrs. Smith lay dead in a pool of blood.

By 1:00 p.m., the Suffolk County coroner, Darling B. Whitney, had been called to the Smith house. When he arrived, he saw there was blood not only underneath the victims but in the middle of the floor as well. Drops of blood could be traced throughout the house, along with bloodied footprints. The hammer and axe were found at the crime scene.

Following is an excerpt from Darling B. Whitney's deposition:

Alexander lay with his head from the fire place, his body was chiefly consumed up to his 3rd or 4th rib. His body was examined in his presence by Dr. Ray; there were three wounds on the left side of his head, immediately over the lower portion of the cartilage of the left ear—making three holes through the cartilage; large cut at the interior and posterior cartilage of

The Smith-Gardiner House in an undated photo before renovations were made. *Collection of the Greenlawn-Centerport Historical Association.*

the same ear. The skull was fractured on the top of the head. The wound must have occasioned the death—wounds must have been inflicted with some heavy instrument like a hammer, with a flat end. No appearance of his having struggled. He thinks the deceased must have been lying upon his back when the wound upon the top of his head was inflicted.

Mrs. Smith was lying in the right corner of the fireplace; her head at the corner of the hearth. She has two wounds upon the forehead, one producing a fracture of the skull, the other a depression. There were four wounds upon the upper and posterior part of the head, one creating a depression of the bone—supposes the same instrument must have inflicted the wound that caused the death of Alexander—her dress was bloody down to her waist; supposed some of the wounds on Mrs. Smith's head to have been inflicted when she was lying down. Her death must have been occasioned by the wounds referred to. She seems from appearances to have struggled. There was blood in the middle of the floor, and spread to the place where she lay. From their positions, thinks Mr. Smith must have been killed first.

Word of the double murder spread quickly. The local newspaper, the *Long Islander*, wrote the following on November 18, 1842. It was entitled "Horrible Murder!":

Never has it been our melancholy task, on any former occasion, to present to our readers the details of a murder, so atrocious in every feature, as the one committed a few nights ago in the vicinity of our village. We do not remember to have heard of one so appalling, for many years.

On Sunday evening last, Mr. Alexander Smith, extensively known as a worthy and wealthy farmer, residing at Old Fields, and his wife were murdered. Their bodies were discovered on the following morning, lying on the hearth; that of Mr. Smith nearly consumed by the fire into which it had fallen, on receiving a blow from the assassin; and that of Mrs. Smith, near by, weltering in blood which had flowed from several wounds inflicted on the head.

It was unheard of that anything of this nature could occur in such a quiet and peaceful farming community. Before long, the dreadful news spread throughout the nation.

Several days after the murders, Antoine Keisler was caught in Port Jefferson. On June 5, 1843, he was convicted and executed for the double murder of Alexander and Rebecca Smith.

Smith's only daughter, Fannie, eventually married Joel Gardiner, and they had six children. One of them was Alexander Gardiner, who inherited four hundred acres of property from his mother. He became the most successful pickle farmer in Greenlawn.

Today, the Smith-Gardiner House quietly holds the secrets of its history, from a horrifying murder to the success of a hardworking man.

The Mad Killer of Suffolk County

ISLIP, SMITHTOWN, WESTHAMPTON BEACH

S uffolk County was turned upside down in the summer of 1959 when a string of three random murders took place in the towns of Islip, Smithtown and Westhampton Beach over a period of eight days. Behind the heinous crimes was a man named Francis Henry Bloeth.

A little before 1:00 a.m. on August 9, 1959, a man entered Bailey's Restaurant, a diner in Westhampton Beach. He ordered a fried egg but never ate it. Instead, he tied up and shot, execution-style, a fifty-year-old waitress named Irene Currier, who owned the diner with her husband.

Her body was found at 1:20 a.m. by a customer who entered the diner. According to police reports, the customer went into the diner to get a cup of coffee. Not seeing anyone around, he started to call out. No one answered. He went toward the back and peered into an "Employees Only" door when he happened to notice that the restroom door was slightly ajar and it appeared that something large was on the floor. Opening the door further, the customer made the grisly discovery. A woman lay in a pool of blood, bound at her hands and feet with kitchen towels and another towel wrapped tightly around her neck. A scarf was also stuffed in the woman's mouth, and a bullet hole was through her left temple.

The customer immediately notified the police. Upon their arrival, the police saw the plate with the untouched fried egg on the counter and noticed that the cash register drawer was open and all the money gone.

Bailey's Restaurant had been open only a few months before the crime took place. For years, Irene and her husband, Edward, had dreamed of owning

their own diner. The couple had saved their money from work they did in New York City as a waitress and bartender. Edward Currier was devastated when police called him in at 2:30 a.m. and told him the dreadful news.

As police canvassed the area, they came across a witness who said he saw a man running out of the diner around 1:00 a.m. and into a car before quickly speeding away. The witness sensed something was amiss, so he jotted down the make and model of the car, as well as a few letters on the license plate. Another lead soon developed. A grocery store clerk told police that a man acting strange had come into the store asking to exchange a large number of coins for bills. He appeared to be very nervous and decided to flee the store before making the exchange. Police believed the coins were stolen during a robbery and that this killer was the same one who had robbed and murdered Hans Hachmann, owner of John's Delicatessen in Islip, and Lawrence Kircher, who worked at Diane Diner in Smithtown. Those murders had taken place just days before. Police stated that the other two murders were "carbon copies" of the robbery-murder that took place in Westhampton Beach. It was believed that the "mad killer" had ordered Irene Currier to her knees and fired a single shot at close range. The bullet went through the victim's left ear, out her forehead and then into the wall. A .32-caliber pistol was used. The police believed the killer ordered the egg before committing the crime because there may have been a customer in the diner who he was waiting for to leave.

The news of the killer made daily front-page headlines. Citizens of Suffolk County were terrified with this "Mad Killer" on the loose, and hundreds of police officers were assigned to a manhunt.

Evidence led the police to a former convict, twenty-six-year-old Francis Henry Bloeth, from Islip Terrace. Bloeth had been arrested twice in 1952 for grand larceny in the theft of automobiles. At first, Bloeth denied having anything to do with the robberies or the murders. Holsters for a .32-caliber pistol were found at Bloeth's home, however. The questioning continued, and Bloeth sought counsel. He had Sidney R. Siben, an attorney from his sister's law firm in Bayshore, represent him. Siben advised Bloeth not to make a statement. Bloeth's sister and mother, on the other hand, begged him to tell the truth and to cooperate with the police. Soon after, Bloeth confessed and admitted that he was the "Mad Killer" of Suffolk County. In a cold-blooded statement, he confessed to the Currier murder, for which he was tried, but he also confessed to the Islip and Smithtown robberies and murders, as well as a rape, another robbery and an assault on an elderly woman for which he used a claw hammer. He showed absolutely no remorse

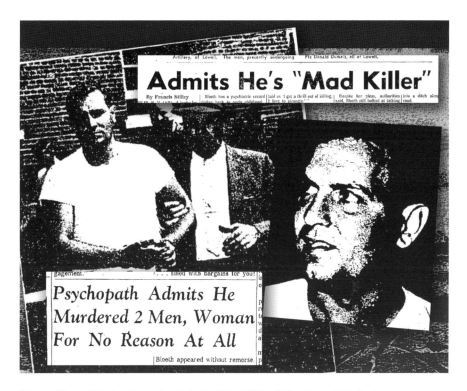

Francis Henry Bloeth admits that he's the "Mad Killer." *Graphic by Linda Paris.*

or emotion and even stated that he had fun killing his victims and that he especially liked strangling Mrs. Currier. Bloeth then told police where he had disposed of the gun he used to shoot Irene Currier. It was found in Lake Ronkonkoma where Bloeth had thrown it. Ballistic tests confirmed it was the gun that had been used in the Currier murder. Prior to Bloeth's confession, Siben had told the district attorney that his client was insane. Siben was not present when Bloeth gave his confession, but he described Bloeth's case as "the worst case I've seen in my 25 years as a lawyer....Killing meant nothing to him. He is a sick man and needs treatment."

The district attorney determined that Bloeth was sane when he committed the murder, that it was premeditated and that he deserved the electric chair.

Because of the high publicity of the case, it was difficult to find a jury. A change of venue for the trial was requested by a man named Clarke who had taken over the defense. The court argued that a fair trial could still take place in the original location, and eighty potential jurors were called in. It took five days to obtain a jury of sixteen people. The trial officially began

in Riverhead on April 19, 1960. For ten days, evidence was presented to the jury, including Bloeth's confession. There was a break in the case when a man by the name of Robert Walsh, a twenty-one-year-old from Islip Terrace, told police that he had sold a .32-caliber revolver to Bloeth several months before and that he sold a .32-caliber automatic to him a few hours before the third killing took place. Walsh was a convict as well, and he was arraigned several days later on a felony charge of illegal possession of weapons.

Psychiatrists on both sides testified on a defense of insanity. When Bloeth finally took the stand, he spoke about the crimes he committed when he was seventeen, including strangling nine cats while he was living in the Lincoln Home for Boys. He also spoke about the history of his behavior and his narcotic use, and then he claimed he did not remember killing Irene Currier or making a confession. He said he did not remember assaulting the elderly woman with a hammer either.

During questioning, his mother said that he was sent to Bellevue Hospital for psychiatric observation after the incident with the cats but that the

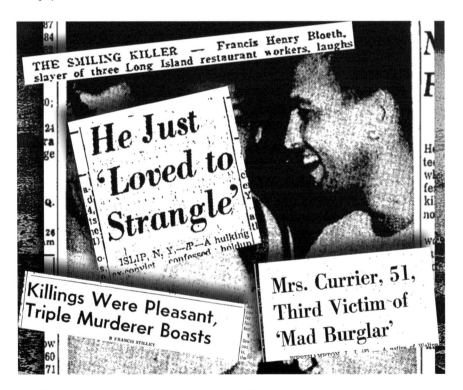

The "Mad Killer" admits to having enjoyed the killings. *Graphic by Linda Paris.*

doctors found him "sane and able to tell right from wrong." His mother then went on to explain that she believed his crime spree was due to a thirty-foot fall from an apple tree, in which Bloeth fell on his head at age seven, and also because of a recent car accident he had.

Bloeth's wife, Jane, also took to the stand and said she first met her husband in 1951, when she was working as a waitress in Greenwich Village. They would have been celebrating their second wedding anniversary, and they had a child together, Karen, who was eight months old. She told the jury that she knew he was troubled and spoke of some of the things he had done.

After thirteen hours of deliberation, the jury found Francis Henry Bloeth guilty of murder in the first degree on the first count, not guilty on the second count of felony murder and guilty on the third count of robbery. The jury called for a mandatory death sentence. Bloeth was then transferred to Sing Sing Correctional Facility in Ossining, New York, where he awaited his execution.

Two years later, Bloeth's attorney managed to get him a second trial, claiming that "publicity" had made the jurors biased. So in 1962, the second trial took place, this time in New York City. Bloeth was once again found guilty and was given a death sentence for the second time. He was sent back to Sing Sing, but three years later, in June 1965, the death penalty laws changed. Only those criminals who had killed members of the police force could be executed. Francis Bloeth and seventeen other death row inmates were granted clemency. Bloeth's death sentence was changed to a life prison sentence.

For twenty-two years, Bloeth remained behind bars. Then, in March 1981, he was paroled from the Auburn Correctional Facility in Upstate New York at a cost of $300. Francis Henry Bloeth, despite the murders, was now a free man.

It is unknown whether Francis Bloeth is still alive. Published reports stated he was living in Syracuse for a while and that he was working as a word processor. The last report came from an article written in 1990 in the *Syracuse Herald Journal*. The paper wrote, "Bloeth was currently employed and trying to live a good life."

The Murder of Captain James Craft

GLEN COVE

The murder of wealthy sea captain James Craft of Glen Cove is probably one of the most disturbing and grisly tales there is. Although not much is known about the victim, his story is worth telling.

On the night of September 27, 1902, when the dreadful event took place, Captain Craft was in New York City in what was called the Tenderloin red-light district. Around 2:00 a.m., Craft arrived at the Empire Café at the Hotel Empire, which was located at 38 West Twenty-Ninth Street. The Empire Café, part of the Hotel Empire, was a place known for drinking and prostitution. Every night around 1:00 a.m., the police would come by and chase everyone but the employees away, and then the main entrance door would be locked. Forty-seven-year-old Craft, apparently knowing about the nightly routine, entered the establishment through a secret door of a Chinese restaurant that was located in the basement. Craft was already under the influence of alcohol when he made his way upstairs with a prostitute he had just met by the name of Mamie Turner and a thirty-six-year-old waiter by the name of Thomas Tobin. The three went into a back drinking room and sat down behind the cashier's desk, where Craft ordered Tobin to bring in beer and whiskey.

When Craft went to pay, Tobin noticed that Craft had a roll of bills totaling about twenty-five or thirty dollars. What Craft didn't know was that Tobin was an ex-convict who had spent nineteen years of his life in prison for robbery.

The three sat and drank for a while until Mamie Turner was called away and never returned. Eventually, the bar emptied out, and the only ones left were Craft, Tobin and a bartender by the name of Alexander McEneaney. Tobin and Craft continued to drink through the wee hours of the morning until they were completely intoxicated. Around 5:00 a.m., from the barroom, McEneaney heard Craft and Tobin arguing about money in the other room, and then he heard the sound of someone falling to the floor. When he came in to see what was going on, he saw Tobin on top of Craft, kicking him and tearing his clothes. Craft's face was swollen and bloodied.

McEneaney tried to push Tobin off Craft and screamed, "Tobin, what are you doing?" With that, Tobin, not saying a word, stepped over Craft and went into the barroom. McEneaney followed after him and then went and got Craft a brandy and tried to make him drink. The man was too heavy for McEneaney to lift, and he could not open the captain's mouth to get the brandy in. McEneaney called out to Tobin to come and help. Tobin came back into the room, and McEneaney went away to wash off the blood that had gotten on his hands when he tried to help. When he returned, Tobin had taken Craft by his feet and dragged him down the stairs to the basement. Craft's head bumped on each step. When he got to the bottom, Tobin left Craft lying there. McEneaney, horrified, went to the bottom of the steps and tried to pick Craft up by the arms to prop him up. He yelled to Tobin to open the door to the Chinese restaurant so Craft could get some air. Tobin went into the restaurant while McEneaney raced back up to get more brandy and a towel for the blood. Craft seemed to have been bleeding from his ears. By the time McEneaney returned, he heard Tobin talking and swearing and found him standing over Craft with a meat cleaver.

"For God's sake, what are you doing?" screamed McEneaney as he tried to push Tobin away. Tobin pushed him back and told him to mind his own business. McEneaney stood there in utter disbelief when he saw that Craft's head was nearly chopped off. Tobin then ordered McEneaney to take off his shirt because it was covered in blood. Fearful that Tobin would come after him with the cleaver, he did as he was told, and as soon as his shirt was off, McEneaney pushed Tobin, shirt and all, and ran upstairs.

McEneaney, in a state of shock, put on his coat and hat, took a drink and picked up a bottle, which he could use to defend himself if need be. He then crept back down the stairs and, to his horror, saw Tobin holding Craft's head, which had been completely severed from the body. As Tobin walked toward the furnace with the head in his hands, McEneaney ran upstairs and

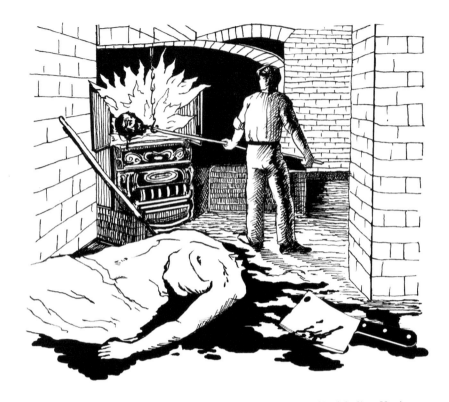

The scene of the beheading and murder of Captain James Craft. *Sketch by Joan Harrison.*

out the door. He called a cab and went straight to the police station, where he informed them of the murder that had taken place.

Meanwhile, upstairs in the hotel, guests were complaining of a foul smell. Little did they know it was burning human flesh, smoldering in the furnace below.

When the police arrived, they found Craft's body completely naked and decapitated under a pile of rubbish. A trail of blood from Craft's body to the furnace was found on the floor, as well as a two-foot pool of blood in front of the furnace door. As the police peered into the furnace, they discovered clothing and the charred head of James Craft. The draft of the furnace did not work, and the fire was now nearly out. Tobin, in a desperate attempt, had tried to make it so that the body could not be identified.

The police immediately began to search for Tobin, who they quickly found, covered in blood and hiding in a saloon. In his pockets, Tobin had

the money he stole from Craft, and nearby, the cleaver from the Chinese restaurant was found.

An autopsy on Craft revealed that all of his organs had been in healthy condition at the time of the murder. It was determined that it took thirteen blows for Tobin to sever the head. There was a fracture of the head, but the physician did not believe that the fracture is what killed Craft. He believed that the sea captain was still alive, his heart beating, when he was beheaded.

Craft was the first person who Tobin had murdered. His previous conviction was for grand larceny. In October 1898, Tobin was transferred from the state prison at Dannemora to the Matteawan State Hospital for the Criminally Insane, where he was apparently treated and deemed "cured." He was sent back to the prison on December 13, 1900, and he was released after nineteen years. It was at this time that he became employed as a waiter at the Empire Café.

A little over a year after Craft's murder, in October 1903, a trial took place, and McEneaney served as a witness. He was indicted with Tobin but was not tried with him. After eight days, the jury decided that Thomas Tobin was of sound mind when he committed the crime against James Craft. They found Tobin guilty of murder in the first degree, and he was sentenced accordingly.

On March 14, 1904, Thomas Tobin was put to death in the electric chair at Sing Sing Correctional Facility in Ossining, New York. It was reported that as he walked to his fate, Tobin recited prayers that his mother had taught him. He was strapped into the chair, and after three shocks to his body, justice prevailed and Tobin was pronounced dead.

Jealousy Leads to Murder

QUOGUE

The small hamlet of Quogue is located on the South Fork in the town of Southampton and was founded in 1659. Because of its proximity to the beach, by the late 1800s it had become known as a summer resort town. Boardinghouses and cottages where people could spend their summers were popping up everywhere. A stagecoach bringing vacationers to and from the beach was often seen going down Beach Lane. It was on this very road, unfortunately, where a tragic murder took place.

The year was 1911, and the summer was coming to a close. The visiting families would soon be packing their bags and heading back to their full-time residences. Two families in particular had been summer residents in Quogue for many years. They were the Childs and Van Wyck families. William Childs Sr. and his wife and two sons, Alfred and William Jr., were prominent social figures from Englewood, New Jersey. William Sr. was a retired electrician who helped develop the telephone, and he also owned a large fruit farm in California. They had vacationed for many summers in Quogue, where they rented one of the local cottages.

The Van Wyck family, who resided in Brooklyn Heights, was quite prominent as well. Mr. Van Wyck was retired from the Standard Oil Company. He and his wife had two children, Katherine Ladd and Samuel Barent. Each summer they headed out to their beach house, which was known as the Van Wyck Cottage. It was located on Beach Lane.

The Childses and the Van Wycks lived a few doors down from each other, and William Childs Jr. and Katherine Van Wyck, who were only a year

An early postcard of Beach Lane in Quogue. *Collection of the Quogue Historical Society.*

apart, became great friends. As the years went on, William Jr. developed romantic feelings toward Katherine, but apparently she insisted they just remain friends. By the summer of 1911, William, now twenty and a graduate from Princeton University, had become somewhat obsessed with Katherine, who was now nineteen. She was not only beautiful but also smart, having graduated from the Packer Collegiate Institute for Girls. That particular summer, other boys residing at summer residences began to notice her. At times, Katherine would flirt with them. Despite his attentiveness, William could not win her heart. She was indifferent when it came to him, and he quickly became jealous.

On the afternoon of September 4, 1911, the two, along with many others their age, attended a baseball game in Quogue. When the game was over, Katherine began to walk home. Soon William was by her side, but according to those who saw them, there was nothing unusual going on between them. Like in past summers, the Van Wycks were residing in their cottage. Mr. and Mrs. Childs had sold their home in Englewood and moved to Lake George in upstate New York. That year, they had decided to stay in Lake George rather than come down to Quogue. Their son Alfred had rented a cottage from Miss Alice W. Howell that was not far from the Van Wycks' house. William sometimes stayed with his brother, but oftentimes he stopped at Cooper House down the road.

So William and Katherine were making their way back down Beach Lane to where they were residing, seemingly having cordial conversation. All of a sudden, William took out a revolver and shot Katherine twice, once in the breast and once in her side. From a distance, there were several eyewitnesses who saw William shoot the girl. As she fell, William took off running and broke through a fence that led into a cornfield owned by Selden Hallock. A passing car saw Katherine bleeding alongside the road and quickly picked her up and drove her home. The incident occurred only about 150 yards from the Van Wyck Cottage. Even more horrifying was that Katherine's mother

An early postcard of the fieldhouse located at the baseball fields in Quogue. *Collection of the Quogue Historical Society.*

and brother, Samuel, who was seventeen, were sitting on their porch when the incident took place. They had been watching the couple making their way home when they saw William take out the gun and shoot Katherine.

Pandemonium broke out in the usually quiet beach town. Mrs. Van Wyck and Samuel ran toward the racing car where Katherine lay. Once Mrs. Van Wyck saw her daughter, she collapsed. Others who witnessed the crime took off into the cornfield after William, where they heard another gunshot. The sound led Bert Pierce, the village constable, and former assemblyman Enistus Post to where William was lying unconscious in the field. He was barely breathing, and to their astonishment, they saw that he had pulled the gun on himself—a bullet through the center of his forehead.

The town doctor, Dr. Greer, was rushed to the Van Wyck house, where he examined the girl. He confirmed that Katherine had been shot first in the breast. The wound was near her heart, and apparently a large artery had been severed, causing her to die almost immediately. It was unknown why William shot her again in her side.

Meanwhile, Pierce and Post carried William's body from the cornfield and brought him over to the barn of the Quogue House, where he died. The lives of members of both families were shattered.

According to those who knew the young man and woman, several claimed that William had asked Katherine to marry him and that he wanted to take her with him to California, where he would run his father's fruit farm. She had declined his offer, and many believe that on that dreadful day, William had made one last attempt to try to convince her.

The Samuel Jones Murder

MASSAPEQUA

It was the summer of 1873 when a brutal murder took place in the quiet town of South Oyster Bay, which today is Massapequa.

The story begins at the home of seventy-year-old Samuel J. Jones, a bachelor and scholar who could speak five languages. He was the grandson of Chief Justice Jones of New York. Many people thought Samuel was an eccentric recluse who buried himself in his house reading books and manuscripts. His home was a modest size, set back from the road, and was located north of the railroad tracks at what once was the South Oyster Bay depot. Elsewhere on his property was another smaller home, which he rented out to a man by the name of Peter Maloney and his family.

One Saturday morning, Peter went to Samuel's house to discuss possible employment. When he knocked on the door, Samuel did not answer. Knowing it was unlikely that he would be out and about somewhere, Peter started looking around the property to see if maybe he was outside. He stopped momentarily at the well to get a drink of water when he made a terrible discovery: Jones had been bludgeoned and thrown into the well to die.

When the police arrived, they discovered that the house had been ransacked. No money appeared in Samuel's pants pockets, so it was believed that he was beaten and robbed. There was very little evidence of who could have done such a deed, so a series of inquests began. Samuel's brother Thomas stepped forth to say that he had visited his brother the night before his body was discovered. The train station master had also seen Samuel that

same evening around 7:30 p.m. Apparently, he was putting out a small brush fire on the land adjacent to the railroad tracks.

By the fourth inquest, which took place on November 23, 1873, a woman who lived just north of Samuel Jones's property came forward. Her name was Mary Murphy, and she claimed to have seen three "Negro males" clearing scrub oak in the area. Samuel Jones apparently hired them on occasion to clear scrub oak on his property, and Samuel often complained to Mary that the workers' prices were too high. She also mentioned that these same three men also helped Jones put out brush fires on his property that were started by embers coming off the smokestacks of passing locomotives.

Another gentleman who lived nearby, William R. Williams, testified as well and stated that on the Friday night when the murder was thought to have taken place, he, too, saw three "Negroes." He recognized one of them and said that his name was Lewis Jarvis. He also mentioned that his neighbor Lewis Jackson told him he had seen two "colored" men acting suspiciously in the area on the night the murder took place.

The suspect who Williams and Jackson identified was described as a heavy-built, fifty-year-old mulatto-skinned farmer who owned and worked several acres nearby. It took many months after the inquests to gain sufficient evidence to warrant arrest. Almost a year later, in October 1874, Lewis Jarvis and his thirty-five-year-old cousin Elbert Jackson were arrested. After the arraignment, Jackson confessed that he did in fact take some of the money stolen from Samuel Jones but that his cousin Lewis Jarvis was the one who committed the murder. Angered by his confession, Jarvis revealed that the idea for the scheme was actually Jackson's. Shortly thereafter, Jarvis directed the authorities to a place where he had buried a small trunk that contained stolen articles from Samuel Jones's house. It was not far from where the murder had taken place.

The first trial that took place was on November 30, 1874, and was for Lewis Jarvis, who pleaded not guilty. The case became quite public, and sixty men had to be screened for the twelve-person jury. Four judges presided over the case. The defense attorney claimed his client was intimidated into confessing to the crime and tried to make a case out of it. The justices, however, would hear no such thing and disallowed the claim. The defense counsel then tried to get a reduced charge of second-degree murder from first-degree murder. After fifteen minutes of jury deliberation, the jurors came back to the judges with a verdict charging Lewis Jarvis with first-degree murder.

Elbert Jackson's trial began immediately after the conclusion of his cousin Lewis's trial, in December 1874. By this time, news of the case had become so widespread that one hundred potential jurors had to be screened for the twelve juror slots. The witnesses from the first trial were interrogated again, as were Lewis Jarvis and his wife. The counselor for Jackson's trial tried to rid the court of the indictment by claiming that there was no mention of Samuel Jones's possible death by drowning. After two and a half hours of closing arguments and an hour of deliberation, the jury came forth with a guilty verdict of first-degree murder for Elbert Jackson.

Both men were then brought into a packed courthouse for sentencing. One of the justices, Judge Armstrong, made it clear to the men that there would be no leniency or pardoning when it came to their sentencing. He said that they "had shown no pity on the elderly Samuel Jones, despite his wounds and condition, in finishing him off." The judge then sentenced them to death by hanging between the hours of 10:00 a.m. and 2:00 p.m. on January 15, 1875.

The sentence created quite a stir in the community because there had not been a hanging in what was then Queens County for twenty-three years, since 1853. Sheriff Sammis went to a supplier in New York City to rent a gallows, which was erected in the courthouse yard. A high fence also had to be built around the gallows to prevent passersby from seeing the execution. An executioner was called in, and arrangements were kept as quiet as possible. The sheriff did not want morbid onlookers to attend.

While the arrangements for the executions were being made, Reverend Charles Backman of Port Washington visited Jarvis and Jackson in jail twice a week, as did their family members. Even the Town of Hempstead Supervisor Seaman N. Snedeker paid the men a visit as it got closer to the executions. Elbert Jackson confessed to the supervisor that he was the one who struck Samuel Jones first. He also confessed to two unsolved burglaries.

The night before the executions, Lewis Jarvis's wife was allowed to stay with him, and the two stayed up all night. Elbert Jackson was alone and slept. The next morning, Supervisor Snedeker drew up a will for Jarvis, leaving all his property to his wife. Oddly enough, Snedeker had been a childhood friend of Lewis Jarvis, who had been employed by Snedeker's grandfather.

By 10:00 a.m., Jarvis and Jackson had been visited by Sheriff Sammis and Deputy Sheriff Rushmore, who read them their warrant of execution. The men were each given a new black suit and a new pair of shoes. A flower was also given to them and was pinned to each of their lapels. Reverend

Backman and Reverend Davis came to the men one last time to perform a religious ceremony that would prepare them for execution.

Despite trying to keep the news of the execution day quiet, 1,000 people came out from all over the county to attend the hanging. Only 150 of those had been formally invited to attend. Captain Woglom of Brooklyn and a twenty-man squad from Brooklyn and Long Island City came to help Sheriff Sammis keep order in the community. It was a cold and blustery winter day, and people slipped around in the snow and ice. Only those who were invited to attend were allowed near the gallows. A special area was set up just outside the enclosure for members of the press who were covering the story. Planks were set up that would allow them visual access over the fence.

Lewis Jarvis mounted the gallows first, followed by his cousin Elbert Jackson. Ropes were attached to the noose around their necks, and black

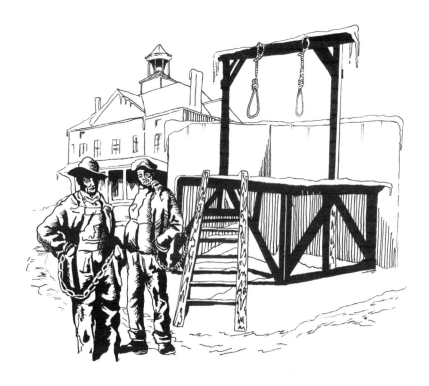

The scene of the awaited execution of Lewis Jarvis and Elbert Jackson. *Sketch by Joan Harrison.*

caps were placed over their heads. The signal was given at 11:25 a.m., and the only sound heard was that of a hatchet slicing through the rope. The weights went down, and the men were raised off the platform. Jackson died immediately and dangled motionless. Jarvis, however, was jerked about two feet up before the rope broke, causing him to fall with great torment, to the horror of the spectators.

Two minutes later, a new rope was set up and ready to be attached to the noose when, all of a sudden, the rope was ripped from the hand of Deputy Sheriff Rushmore and quickly went through the eye of the beam, delaying things even more. By the third attempt, Jarvis said, "Try and make a better job of it this time." As soon as he said those words, several men raised him by hand, since it would have taken too long to get the weights back on. Jarvis was pronounced dead at 11:42 a.m.

Funeral services for the men were held almost two weeks later, on Sunday, January 31, 1875, in the basement of the Jerusalem AMZ Church. Several sermons and speeches were given, including one from Supervisor Snedeker. The *Queens County Sentinel* reported that because Lewis Jarvis had spent time serving in the Civil War and had seen bloodshed, he came back home as "a desperate character." Others claimed that rum was what drove Jarvis and Jackson to murder. Supervisor Snedeker defended against these reports.

The real issue quickly became capital punishment, especially in light of Jarvis's botched hanging. Thirty years prior, Horace Greeley, *New York Herald Tribune* editor, had led a fight to abolish capital punishment in New York State. By the middle of the century, only murder and treason remained capital crimes in several northern states. During the time of the Jones murder, conflicts arose as to the leniency of these laws. Some thought the law was too lenient, while others thought it was not lenient enough.

The *Long Island Democrat* stated, "The paper believed there was ample freedom for juries to show mercy by imposing a life sentence. But for premediated and deliberate homicides like that committed by Jarvis and Jackson, death was the only adequate punishment. The 'unfortunate accident' during the first attempt to hang Jarvis was seen as no justification to abandon the death penalty."

Reverend Backman decided to write an editorial and publish the confessions of Jarvis and Jackson in order to "banish all question [for any] who had doubts as to the verdict and punishment of the men."

In contrast, the *South Shore Observer* opposed capital punishment but did agree that in the case of Jarvis and Jackson, it was justified. The question

remained, however, "whether Christianity assumes to approve the taking of life given by Him who [does] all things well, and who alone should be the taker of what He only can give."

By 1965, New York had become the twenty-third state to abolish the death penalty with the exception of the murder of police officers or a murder committed by a prisoner already under a life sentence.

The Wickham Murders of 1854

CUTCHOGUE

The Wickham family of Cutchogue has an extraordinary history that dates back to the 1600s. Throughout the centuries, they have made great contributions to the North Fork community, and their family farm is still going strong.

Much of the excerpts in this chapter have been taken from my book *Ghosts of Long Island: Stories of the Paranormal*, which I wrote in 2006. At the time, I had the privilege of interviewing Tom Wickham, the current owner of the farming business.

The Wickham family history can be traced to the southern coast of England. By the middle of the 1600s, the family had fled their homeland for religious reasons and sailed to New England. One of its members, Joseph Wickham, settled on Long Island and operated a tannery in Bridgehampton. In 1698, he moved to Cutchogue and bought the old English house and 160 acres of fertile farmland that ran from the main road south to Peconic Bay. Joseph Wickham farmed the land until his death in 1732, at which time the land was willed to his eldest son, Joseph Jr. Amazingly, the land today is still being farmed by descendants of Joseph Wickham.

The old farmhouse remains on the Cutchogue property, although a much larger addition was attached to it during the early nineteenth century. Perhaps even more surprising is that the Wickhams' landholdings have increased to three hundred acres, which is an astounding amount of land for one family to own on Long Island. Two hundred acres are used for farming, while the remaining one hundred acres comprise the water, beaches, woods and the

Wickham Farmhouse as
it appears today. *Photo by
Kerriann Flanagan Brosky.*

land on which their houses sit. The farm is not only one of the oldest in New
York State but is also one of the oldest farmlands in America.

It is unfortunate that a family so built on love, religion and community
could have a great tragedy befall them. The Wickham murders of 1854 were
one of the most horrifying events to take place on the East End.

James Wickham, who was married to Frances Post of Quogue, had left
his grocery firm of Wickman and Corwin in New York City to retire to the
family farm in Cutchogue. He farmed the land with a black servant and
an Irish farmhand named Nicholas Bain. (A later source from 1962 lists
Nicholas's last name as Beham, but the name Bain appeared in the original
June 6, 1854 copy of the *New York Herald.*)

According to written descriptions, "Bain was a huge, black-haired fellow
who walked with a long, rolling gait." He had worked for Wickham for two to
three years. Supposedly, Bain had a drinking problem and would often make
advances toward the servant girls. One girl in particular, Ellen Holland, he
had asked to marry. Upon her rejection, Bain became very angry. James
Wickham argued with him, having had enough of the turmoil Bain was
causing on the farm. On Wednesday, May 31, 1854, Wickham terminated
Bain's employment. Bain continued to hang around and torment Ellen. By
Friday morning, June 2, Bain was forcibly evicted from the farm by James
Wickham.

Nicholas Bain left for the railroad station in Greenport, all the while
screaming for revenge on Wickham. He did not board a train; instead, he
checked his bags in town and began the ten-mile walk back to Cutchogue.
By eleven o'clock that night, he was back at the farm and all was quiet.
Searching through the yard, he came across a pole axe, picked it up and
headed to the farmhouse.

Minutes later, two servant girls living in the house heard the screams of Mrs. Wickham and the sounds of someone being beaten. Then Mrs. Wickham cried out, "Nicholas, don't kill him, don't kill him!"

The girls, fearing for their own lives, escaped through the windows just as Nicholas was entering their room. They ran to the neighbors, and Joseph Corwin, William Betts and Dr. Carpenter came immediately to the Wickham farm. The following is an excerpt from the *New York Herald* in 1854:

Mr. Wickham lay weltering in his blood, his head literally cut to pieces. Mrs. Frances Wickham, his wife, was dead, she having had her brains completely knocked out, which, together with her blood, was scattered about the room. Mrs. Wickham was but thirty-five years of age. A Negro servant boy, about fifteen years old, who was living with the family, was also beat and cut about the head to such an extent that he cannot survive his injuries; and he, too, is in such a condition as to be unable to give any account of the desperate murderer.

The murderer was most definitely Bain because he had left his hat behind in the rush to escape. Also, his very large bloody footprints tracked away from the house. Because of Bain's size, only one person could have made those footprints.

A manhunt began. The Wickham killings were the first murders the town of Southold had seen in thirty years. That, coupled with the fact that everyone knew and liked the Wickhams, caused the town's inhabitants to erupt in fury. Hundreds of men set out with pistols and rifles, looking for the murderer. At this point, Bain was successfully hiding in the woods. Days went by, and the enraged men kept searching the woods, the hills and the valleys. On the morning of the Wickhams' funeral, the discharge of a pistol created a general alarm, and the teams of men knew that Bain had been caught. He had been captured in a south side swamp, east of Cutchogue.

Upon their arrival, the men found Bain, greatly fatigued, with a two-inch wound visible on his throat. The *New York Herald* wrote:

In his pockets was found a single barrel pistol, loaded with small shot, a pocket knife, and a razor case, from which it is supposed he took the razor to kill himself, and after inflicting the wound threw it away. In his pockets was also found bread and cake enough for him to subsist upon for two days. The bottoms of his pantaloons were saturated with blood, apparently from that of his victims.

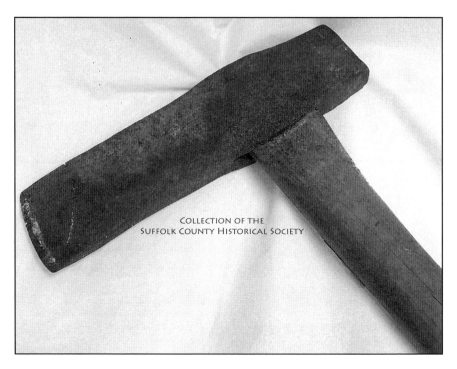

COLLECTION OF THE
SUFFOLK COUNTY HISTORICAL SOCIETY

The weapon used in the murder of James and Frances Wickham. *The Collection of the Suffolk County Historical Society.*

The townspeople wanted to hang him right away and yelled all sorts of slurs at him. The sheriff stepped in and immediately led him to Riverhead, followed by a band of thousands of men and boys. Within four months, Bain had been convicted of first-degree murder. On December 15, 1854, he was hanged in a courtyard behind the jail in Riverhead. The militia from Sag Harbor was called in to keep order within the angry mob of people who showed up for his execution. It turned out to be the largest crowd of spectators ever to attend a public execution in the county.

Once dead, Nicholas Bain's body was taken down, placed in a wooden coffin and brought to the south side of the Peconic River to a place named Egypt. He was buried in an unmarked grave.

According to the local authorities, it was determined that Frances Wickham had died a few minutes before her husband. The Wickhams had no children, and as their wills were written, the farm would have gone to her family, the Posts of Westhampton, had she outlived her husband. It is

because she died first that the farm remained in the Wickham family and why they are still farming the land to this day.

In 2013, fellow History Press author Geoffrey K. Fleming and Amy K. Folk wrote an extensively detailed book on this subject titled *Murder on Long Island: A Nineteenth-Century Tale of Tragedy and Revenge*, for those who may be interested in reading more.

Dentist Shot by Vengeful Mother-in-Law

NORTHPORT

T hrough a bizarre chain of events, a local dentist by the name of Dr. James W. Simpson was shot by his mother-in-law in Northport in July 1908 and lived to tell about it. The motive behind the shooting goes back to another incident that took place on the night of December 27, 1905, when Dr. Simpson "accidentally" shot his father-in-law.

Bartley and Ella "Millie" Horner were respected citizens living in the quiet Vernon Valley area of Northport during the early 1900s. Their only daughter, Julia, had married a dentist, Dr. James W. Simpson, in 1895. The young dentist and his wife lived in Galveston, Texas, for five years until they lost everything in a category four hurricane. They moved back to New York, where Dr. Simpson opened his dental practice at 434 Fifth Avenue in New York City. Dr. Simpson was struggling financially, however, and he and Julia had to move back to Northport and live with the Horners. Mr. Horner argued frequently with Simpson, who was a heavy gambler when it came to horse racing. Simpson even struggled to pay his share of the household expenses.

On Christmas Day 1905, Dr. Simpson went rabbit hunting with a friend. Two days later, on the evening of December 27, 1905, he went into the kitchen to clean the double-barreled shotgun he had used. He placed the gun on a kitchen chair when he saw the Horners' Polish stable boy, twenty-six-year-old Frank Wisnewski, enter the kitchen. He called him over with the intention of showing him how to properly clean a gun. Simpson then pressed the gun against the table to open it, and suddenly both barrels discharged.

He then heard a scream and a loud groan coming from the dining room. Bartley Horner, who had been reading his newspaper, had been shot in the abdomen. Mr. Horner cried out, "My God, Doctor, what have you done?"

Hearing the commotion, Mrs. Horner rushed in and found her husband bleeding on the dining room floor. She screamed to call for a doctor, and Simpson and the stable boy ran out of the house to hitch up a horse. Dr. Heyen and Dr. Donohue from the village rushed over, and they made their best attempt to stop the bleeding. It was too late, however. Within two hours, Mr. Horner had succumbed to his wounds.

An inquest was held the next day, and upon questioning, Mrs. Horner revealed that her husband had feared their son-in-law. Horner had recently decided to change his will so that Simpson would not receive any of his money. Before dinner on the night of December 27, and before Mr. Horner had come home, Mrs. Horner, Julia and Dr. Simpson had been discussing the will. The appointment to see the family attorney had been scheduled for the next day. Horner had died before he was able to change his will. When Simpson was questioned at the inquest, he denied knowing that Mr. Horner was planning on changing the will.

Mr. Horner's funeral was held at his home in Vernon Valley on New Year's Eve. As for Dr. Simpson, he was arrested and brought to the jail

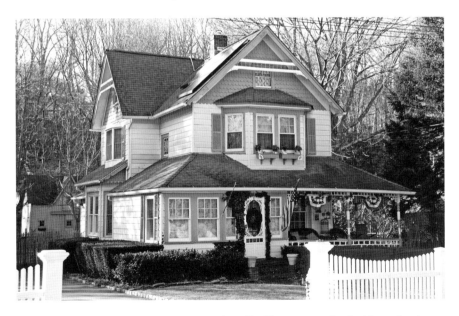

This beautiful home in Vernon Valley was where Dr. Simpson was shot by his mother-in-law. *Photo by Kerriann Flanagan Brosky.*

in Riverhead. Meanwhile, reporters were flocking the streets, and news of the case traveled throughout the country. A week later, there was a preliminary hearing where both Julia and Mrs. Horner testified. There was enough evidence brought forward, so Justice Partridge referred the case to a grand jury. The grand jury, in turn, issued an indictment for murder in the first degree.

The Polish stable boy, Frank, was brought in as a witness, but the young man was extremely distraught and fearful that Simpson would try to harm him. Frank's English was quite poor, which made him nervous. He thought he would not be understood. Frank became quite agitated, and soon he was out of control. He couldn't be calmed down, and ultimately he ended up going to Kings Park Psychiatric Hospital, where he eventually escaped and was found in the woods of Central Islip. Obviously, Frank was incompetent to testify at the trial.

The trial was originally set for May 1906, but oddly enough, the judge who was assigned to the case died. The trial date was then moved to October of that same year, but more delays occurred. All the while, Simpson remained in jail and prepared for his case. Finally, thirteen months after his arrest, Dr. Simpson got his trial. Jury selection took place on January 28, 1907, and hundreds of spectators and reporters came out for it. When Dr. Simpson took the stand, he claimed that he had good relations with Mr. Horner and that the gun going off was an accident. When Dr. Simpson was asked by the district attorney whether his finger touched the trigger the night the gun was discharged, Dr. Simpson replied, "I cannot say, I cannot tell."

A family friend, Dr. Isaiah Frank, was brought in to testify. He had arrived at the Horner home shortly after the shooting. Fearing that Dr. Simpson would pull the gun on himself for having killed his father-in-law, Frank took the gun away and brought it to his home, where he kept it overnight before handing it over to the district attorney. The district attorney questioned Frank and asked him to examine the shells, which were red. Upon seeing them, Frank claimed they were not the same shells that had been in the gun when he had taken it home and examined it. He claimed the discharged shells were yellow. He was quite certain that they were not red. Another question was brought up at the trial, and experts were brought in to determine whether it was physically possible for the gun to discharge when it was opened or "broken."

Despite the inconsistencies, within two hours of deliberating, the jury found Dr. Simpson not guilty of murder, and Simpson was set free. Simpson's wife and mother-in-law could not believe that he was acquitted

and declared that justice had not been done. Dr. Simpson quickly left Long Island and moved to 24 West Fifty-Ninth Street in New York City, where he made the attempt to continue his practice at 1181 Broadway. He also hoped that he and Julia would somehow reconcile.

Mr. Horner's estate was finally settled, and both Mrs. Horner and Julia had enough money to keep them comfortable. Not long after the acquittal, Dr. Simpson, still being married to Julia, had the audacity to start a $5,000 lawsuit against his wife and mother-in-law, claiming that he was entitled to a share of his father-in-law's property. Luckily, the suit was dropped. Knowing that Julia wanted nothing to do with him, Simpson tried to get a divorce, but Julia claimed she "would not free him by divorce" and refused the offer.

On July 13, 1908, a little over a year after Simpson was set free, he took the train to Northport in an attempt to see Julia. Shortly before 1:00 p.m., Mrs. Horner was at her home when the bell rang. When she asked who was there, Simpson said, "Is that you, Millie? It is I." Startled, Mrs. Horner asked him what he wanted. "I want to see Julia," he replied. She looked through the gauze curtains over the glass panels and saw her son-in-law, Dr. Simpson, standing there. She was immediately scared for herself and her daughter. Apparently, they had been living in great fear since Simpson's release. There had been several occasions where Simpson went to Northport in search of Julia, saying he just wanted to talk to her. According to Mrs. Horner, at one time her daughter was accosted by Simpson on the village street.

Through the door, Mrs. Horner informed Simpson that he should leave. She told him that she would not let him into her house. She heard the sound of the jiggling of the doorknob and believed that Simpson was trying to enter the house. She quickly ran upstairs and got a .38-caliber revolver. When she came back down, Simpson was still there, and she told him if he did not leave he would meet his peril. Simpson then began banging on the door and shaking the handle in a desperate attempt to come in. Mrs. Horner saw Simpson make a movement through the window, which led her to believe that he may have a gun. She then raised her revolver and took two shots through the glass door panel. The banging suddenly stopped. Simpson had been shot.

Mrs. Horner looked out the window and saw Simpson stumbling away to her neighbors' house, leaving a trail of blood. Simpson had been shot in the lower lobe of his left lung by only one of the bullets. The other shot had missed him. Along with his lung, severe damage had been done to the center of his liver. Mrs. Simpson opened the door and came out onto the porch.

Dr. Simpson staggers away after his mother-in-law shot him. *Sketch by Joan Harrison.*

Julia, hearing the shots, came running down the stairs and peered out the door, thankful her husband had been shot and not her mother.

Through the whole ordeal, Simpson, despite the tremendous pain he was in, stayed calm. He asked the neighbor for use of a rig so he could go to Dr. Heyen's office on Main Street, Northport. He asked the doctor if his wound was fatal, to which the doctor replied that he was unsure. Dr. Heyen told Simpson he needed an operation, and the doctor offered to do it immediately. Oddly enough, Simpson said no. Instead, he insisted on going back to New York City so he could go to Roosevelt Hospital. Dr. Heyen, meanwhile, was on the phone with St. Mary's Hospital in Brooklyn, where he told them to prepare for Simpson's arrival and that a major operation was necessary. Simpson would not hear of it and still insisted on going to Roosevelt Hospital.

Dr. Heyen gave Simpson morphine for the pain. Magistrate Richard W. Hawkins arrived, and Simpson smoked a cigarette while he explained to him how his mother-in-law had shot him. He signed a disposition, and without any assistance, Simpson got on the trolley and made his way to the

train station despite his critical state. He then took an hour-and-a-half train ride to Long Island City, where he boarded the Thirty-Fourth Street Ferry, and from there he took a taxi to Roosevelt Hospital, with several reporters trailing behind.

Very weak and almost on the verge of collapse, Simpson made his way to the hospital desk and said he needed immediate attention and that he wanted a private room. Upon examination from the house surgeon, Dr. James Harrington, it was decided that Dr. Simpson needed an operation right away. With the assistance of Dr. Lucius Hotchkise, the surgeons had to locate the bullet but were having trouble finding it. Luckily, they knew it was not near his heart, and all his vital signs were good. They decided to put the operation off until the morning when X-rays could be taken. Simpson's condition was still very grave, and until the surgeons found the bullet, they did not know if he would survive. After this point, medical records were unclear. Somehow, though, Dr. James Simpson managed to survive without ever having the operation to remove the bullet.

Authorities were reluctant, meanwhile, to arrest Mrs. Horner, who they had great sympathy for. They had no choice, however, and Constable Hauger was sent to the Horner home with a warrant charging Mrs. Horner with the shooting of Dr. Simpson. When he got to the house, the constable found Mrs. Horner and Julia sitting calmly, waiting for his arrival. Mrs. Horner was told to not tell her side of the story until she spoke to her lawyer, Roland Mills.

District Attorney George H. Firman of Patchogue set bail for Mrs. Horner at $5,000, which was paid by Julia. Mrs. Horner was released and went home with Julia, where she spoke to her attorney. Once Dr. Simpson recovered, he sued Mrs. Horner for $10,000 but only won a verdict of $1,500. A trial was set, and if Simpson had died, Mrs. Horner would have been charged with murder. It was lucky for her that he did survive. Having heard Mrs. Horner's story, the grand jury decided not to indict her.

With both the lawsuit and trial behind them, Julia and Mrs. Horner remained in the house in Vernon Valley. A few months after the trial, they took a cruise to the Orient and then took a cruise around the world together in 1923.

Mrs. Horner died in 1944, and Julia died ten years later. It is believed Dr. Simpson may have moved to Larchmont, New York, and remarried, so maybe he did end up getting a divorce from Julia. When and how he died, however, remain unknown.

Count Rumford and the Old Burial Ground

HUNTINGTON

There were many horrific acts that took place during the American Revolutionary War and stunned the minds of all those who witnessed them. The Old Burial Ground, located in the heart of today's Huntington Village, silently swallowed the scenes of the Revolution that once haunted this sacred ground.

Built high on a hill, this historic cemetery has tombstones dating back to 1712. However, there are more than likely several unmarked graves that date back to the seventeenth century. Unmarked graves were very common through the early years. Other graves that had stones oftentimes got destroyed or disappeared. The Old Burial Ground contains about eight hundred graves, with the last grave being dug in 1948.

The events that took place here are inexplicable, and at the heart of all the mayhem was Colonel Benjamin Thompson, otherwise known as Count Rumford. Born in Massachusetts, Colonel Thompson joined the British after his application for a commission in George Washington's army was rejected. He was not a British count but, rather, a count in the Holy Roman Empire. In an effort to inflict as much humiliation as possible on the Patriots during the occupation of Huntington, British soldiers, under Colonel Thompson, tore apart the Old First Church, located down the road from the Old Burial Ground, and used the wood to build their encampment. Because the cemetery was built on a high hill that faced north, it gave the British soldiers a perfect vantage point. They could see both the harbor and the bay. They decided to call their makeshift camp Fort Golgotha, which is named after

The Old Burial Ground in Huntington, once known as Fort Golgotha, where the British soldiers set up their camp. *Photo by Kerriann Flanagan Brosky.*

the biblical Golgotha where Christ was crucified. Golgotha means "a place of skulls." To the people of Huntington, this use of their burial place was a grievous thing. The rude barracks were erected in the center of the burying ground, and there the British soldiers stayed for three very cold months, ordering wood and blankets from the townspeople.

The aged pastor of the church, Reverend Ebenezer Prime, had been maltreated and called an "old rebel." Not only did the British officers destroy his church, but they also took his house as their quarters, broke his furniture and mutilated and destroyed the most valuable books in his library. Reverend Prime died during the war, in 1779, and was laid to rest in the Old Burial Ground.

During the building of the fort, all the graves had been leveled, and Colonel Thompson pitched his tent in such a position that he would be trodding over Prime's grave, the grave of that "damned rebel," as he called him.

The tombstones were used for making tables and fireplaces. One of the most horrifying incidents the people of Huntington witnessed was the gravestones of their family and friends being used for British ovens. When

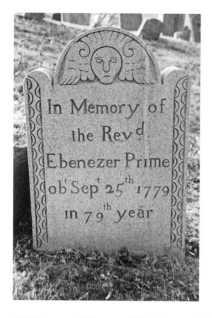
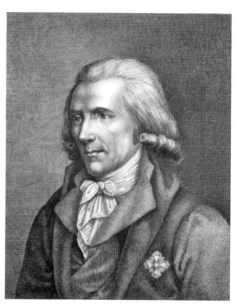

Left: Reverend Ebenezer Prime's grave in the Old Burial Ground. *Photo by Kerriann Flanagan Brosky.*

Right: A portrait of Colonel Benjamin Thompson, otherwise known as Count Rumford.

the loaves of bread were drawn out of the ovens, the reversed inscriptions of the tombstones were imprinted on the lower crust.

Another story speaks of the British commandeering the home of Silas Sammis, who lived near the burying ground. When Silas died and was buried on the hill, it is said that the British used his tombstone for target practice. The stone is said to exist in the cemetery today, bearing the name and date "Silas Sammis 1779," with two bullet holes shot through it.

In March 1783, the British were ordered to evacuate Huntington and leave their fort behind. A year later, in 1784, the townspeople leveled Fort Golgotha, and the bricks, posts and boards used to create the fort were sold by the town at public auction. The proceeds were used to erect a fence around the parsonage. Still, for many years, no one cared to be buried there.

After General George Washington became president, he took a trip through Long Island in 1790 and stopped for dinner in Huntington. He was taken to the burying hill and was shown the site of Fort Golgotha.

There are more than seventy historic cemeteries in the town of Huntington, and the Old Burial Ground is the largest. In 1981, it was placed

in the National Register of Historic Places. Here rest the early town's dead Patriots, soldiers and civilians, among them Silas Wood, author of the first history of Long Island. A memorial is also located at the north entrance of the cemetery for the thirty-nine citizens who gave their lives in World War I in 1914–18.

If you make a visit to the Old Burial Ground today and reach the highest point of the hill, it is easy to envision the angry Count Rumford peering through his looking glass, waiting for the Patriots' arrival in the harbor.

The Tale of Captain Kidd and Buried Treasure

GARDINER'S ISLAND, EAST HAMPTON, OYSTER BAY

Throughout the centuries, people have been intrigued by pirates and the possibilities of discovering buried treasure from long ago. One of the most well-known pirates—no, it is not the fictitious Captain Jack Sparrow—is Captain William Kidd, whose legend continues to live on.

Piracy was at its peak in 1699, and although places like Rhode Island were known to harbor pirates, according to the colonial governor of New York and Massachusetts, Richard Coote, Earl of Bellomont, Long Island was a "great receptacle for pirates." Long Island's East End, with its easy access to inlets, bays and the ocean, was a most convenient place for pirates to smuggle in and bury their loot. Pirates were discovered in East Hampton as early as 1654. Although many pirates stepped foot along our shores, the most notorious was Captain Kidd. William Kidd was born to a Presbyterian minister and his wife in Greenock, Scotland, sometime around 1645. Growing up around the water, Kidd longed for a life at sea.

During the late 1680s, England was at war with Spain and France. It was common practice for governments to hire captains for privateering service. This would allow a captain from a privately chartered ship to legally board and take any enemy ship and its contents. Piracy, on the other hand, was not legal. A pirate was a thief or outlaw who was not commissioned by a government. The pirates would board any ship, enemy or not, and most would keep whatever treasures were onboard for themselves. Captain Kidd at various times in his life was both a privateer and a pirate.

He started off as a privateer in 1689, working with a buccaneering crew in the West Indies. He was then asked by the English government to captain a ship in the Caribbean named the *Blessed William*. By 1691, Kidd had sailed his ship to New York City and met and married a wealthy English woman half his age named Sarah Bradley Cox Oort. They moved into a house on Pearl Street and had two daughters. Kidd and his family became charter members of what is now the oldest church in Manhattan, Trinity Church. Kidd lived a quiet and respectable life for a while, but his hunger for adventure and freedom ultimately brought him back to the sea.

He sailed his ship to London and put in a request to fight French ships for the English government. He was granted a privateering commission, which allowed him to raid enemy ships, as well as attack and raid pirate ships that were interfering with the flow of commerce. So by 1696, Captain William Kidd was once again on the high seas, this time on a new and very impressive 124-foot sailing vessel called the *Adventure Galley*. The ship contained thirty-four cannons, twenty-three oars and a 150-man crew. Kidd and his men were told to set sail to the East Indies via the Indian Ocean, where there were an abundance of French ships, pirates and commerce.

However, Kidd and his crew never came across any French or Spanish ships; therefore, they had no treasure to speak of. After two years of sailing around the Indian Ocean, the crew became quite restless and angry. If there was no treasure to bring back, they would not get paid. As the saying went, "No prey, no pay." Several crew members turned to piracy and wanted to raid any ship they came across. One crew member in particular, William Moore, confronted and threatened Captain Kidd. Kidd, in his own frustration, hit Moore over the head with a bucket, accidentally killing him.

From this point on, Kidd's luck changed for the worse. It was January 30, 1698. Not only had he committed murder, but in his haste to capture a ship, he seized an Armenian-owned vessel called the *Quedah Merchant*, which was rich in cargo. Unbeknown to him, it was captained by an Englishman. When Kidd realized the mistake he made, he wanted to set the ship free. His desperate crew had other plans, though, and a mutiny took place. Kidd was locked in his cabin while his crew raided the ship.

Word of William Moore's death and the capturing of the English captain's ship eventually made its way back to the English government, which immediately issued a warrant for Captain Kidd's arrest for both piracy and murder. Kidd would be difficult to find.

While anchoring in the Caribbean a year later, Kidd was told the news that the English were looking for him. He told his crew to leave, and without

giving them anything, he burned his ship and sank it. Kidd then purchased a smaller trading sloop called the *Antonio* and loaded the new vessel with the treasure he had taken from the *Quedah Merchant*. He decided to set sail for New York, where he would appeal to Lord Bellomont. Bellomont had been one of the original English government officials who had agreed to help finance Kidd's voyage on the *Adventure Galley*. He knew his crew would eventually come after him in search of the treasure, and he knew the English government would confiscate it if found. Kidd realized his only choice was to hide the treasure before meeting with Bellomont.

Kidd's first stop was the remote Gardiner's Island. When he anchored in Gardiner's Bay, he discovered the island was inhabited by John Gardiner and his family. John was the third lord of the manor from 1689 to 1738. Gardiner had been accustomed to pirates coming along his shores. Not knowing whether Kidd was in fact a pirate, Gardiner traded provisions for treasure with him, and his wife prepared a pig roast dinner. In return, Kidd gave Mrs. Gardiner a piece of silk fabric thread with gold. Today, the fabric is preserved and on display at the East Hampton Library.

It wasn't until Captain Kidd said he wanted to bury treasure on Gardiner's Island that Gardiner realized Kidd was a pirate. Kidd threatened him, saying, "If I call for it and it's gone, I will take your head or your son's."

Most of the treasure, which was worth about $30,000, was buried near Cherry Harbor, a ravine between the Gardiners' Manor House and Bostwick's Point. A bronze historical tablet now marks the spot.

It is said that Kidd did not want to bury all the treasure in one place, so he sailed around Long Island looking for hiding spots. Legend has it that after leaving Gardiner's Island, he made his way toward Montauk and buried two chests of treasure by two small ponds near the current Montauk Lighthouse. The ponds have been called Money Ponds for years, as treasure hunters have searched far and wide for Kidd's treasure. Many believe one of the Money Ponds is bottomless and that the treasure simply disappeared. It is believed that after he buried treasure in Montauk, Kidd sailed to Setauket, Centre Island and Cove Neck in Oyster Bay, burying treasure at each stop along the way. He had been very concerned about his crew finding his whereabouts, as well as the treasure, so moving around and hiding it was the best thing to do.

Once the treasure was buried, he made his way up to find Lord Bellomont. Kidd had planned to tell Bellomont where all the treasure was hidden, with the hopes of being pardoned. He had also set aside a small treasure just for him. Bellomont was in Boston when he found out that Kidd was planning to

This historical marker on Gardiner's Island indicates where Captain Kidd once buried his treasure. *Courtesy of the East Hampton Historical Society.*

contact him, and he figured out why. Bellomont did not want to meet with Kidd for fear that he would be charged with trafficking a pirate, so instead, he turned on him and set a trap. He told Kidd to come to Boston to meet him, and when Kidd arrived in Boston Harbor, he was immediately arrested and thrown in Boston's Stone Prison.

There are conflicting stories about whether Bellomont found out through Kidd that treasure had been buried on Gardiner's Island or whether John Gardiner, finding out about Kidd's fate, contacted Bellomont and told him where the treasure was buried. In either case, the treasure was dug up and delivered to Boston. The treasure contained bars of silver, rubies, diamonds, bags of gold dust, pieces of eight, porringers and candlesticks, just to name a few. A list of the items was taken back to Boston, and a receipt was given to John Gardiner. Like the silk fabric, the receipt is on display at the East Hampton Library.

It is said that John Gardiner found a diamond in his traveling bag that was accidentally left behind after he returned from Boston. The diamond was apparently given to the Gardiners' daughter Elizabeth when she married a chaplain.

Meanwhile, Bellomont contacted the English government to let it know that Kidd had been captured and was in his possession. He awaited

A receipt given to John Gardiner listing Captain's Kidd's treasures. *Courtesy of the East Hampton Library, Long Island Collection.*

word on what to do with him. It was decided that Kidd would be returned to England, where he would remain in prison and await a trial. In March 1700, Kidd and his treasure from Gardiner's Island were sent back to England. Kidd was placed in Newgate prison. He remained there for over a year awaiting his trial for murder and piracy. When the trial did come about, it lasted only two days. Captain Kidd was found guilty on both counts and sentenced to be hanged.

All the way up until his death, William Kidd proclaimed his innocence. On May 23, 1701, in a drunken state, he was brought to Execution Dock, which was located along the Thames River outside London. The hanging turned out to be a spectacle. The noose was tied around

The hanging of Captain Kidd in England. *Courtesy of the East Hampton Library, Long Island Collection.*

Kidd's neck, and as he was raised up, the rope broke, causing Kidd to fall. He then had to be strung up a second time until he took his last breath.

To set an example to those who may have been considering piracy, pirates who were hanged were often left hanging for everyone to see. Captain Kidd was no exception. In fact, his body hung over the River Thames at Tilbury Point for three years.

The treasure that was brought over from Gardiner's Island became the property of the English Crown. As for the rest of the treasure supposedly buried along the shores of Long Island, none of it has ever been found.

Gardener Kills Broker in Front of Bride

DUCK ISLAND, ASHAROKEN

It was 1921 when an overprotective gardener killed the husband of a new bride at her summer home on Duck Island in Asharoken before pulling the trigger on himself. The double tragedy shocked residents in nearby Northport, who knew Duck Island to be a quiet and remote island for wealthy summer residents.

Duck Island, which is located off Asharoken Avenue, was part of the estate owned by Sarah Gardiner in the mid- to late 1800s. Ownership of the island changed several times. By 1907, the island was sold to George B. Henderson for $82,000. George was an official of the Chicago Rock Island and Pacific Railroad. He and his wife, Helen, built a two-story mansion facing Northport Bay on the eastern half of Duck Island. Their plans were to use it as a summer residence.

George passed away around 1915. His cause of death and the exact date of his passing are unknown. George and Helen had a daughter together, also named Helen, who was about seven years old when her father died. Upon her husband's death, Mrs. Henderson found out that the property, now valued at $100,000, was actually left in a trust to their daughter. Apparently, the Hendersons' attorney had failed to keep a contract that stated the couple were to share in the purchase, so Mrs. Henderson sued the attorney in the Supreme Court.

Mrs. Henderson and her daughter resided in New York City after George's death, and she kept the house on Duck Island and continued to use it as a summer residence.

A tranquil view of Duck Island Harbor. *Photo by Kerriann Flanagan Brosky.*

By 1920, Helen Henderson's sister had passed away, leaving Helen's brother-in-law, Henry, a widower. Henry and Helen's sister had two boys together who were now adults. A year later, on May 31, 1921, Henry married Helen, and she became Helen Hemming. Right from the start, their marriage was a rocky one.

Henry Hemming was a forty-nine-year-old, inactive broker who still maintained an office at 15 Broad Street in New York City. He had some money, and the papers of the day described him as "being a man of exceptionally large build and magnetic bearing." After their marriage in May, Henry and Helen went back to Helen's home on Duck Island. Helen had employed a gardener, an Austrian man named Frank Eberhardt, for four years. Prior to being a gardener, Eberhardt was a special deputy sheriff. He was very protective of young Helen, who was now about thirteen, and it is believed he may have developed a fondness for Mrs. Hemming as well.

As soon as Henry Hemming stepped foot on the property, he began making demands to the gardener, whom he treated like a second-class citizen. He told Eberhardt that the estate lacked flowers and shrubbery and that he should immediately form several flower beds in the front of the main entrance.

Agitated, Eberhardt replied, "You are not my boss. I know you were married to my employer yesterday, but I'll never take any orders from you around here."

Hemming did not like being talked back to and went into a huge rage, demanding that Helen fire Eberhardt immediately, which she did. However, less than an hour later, Eberhardt's position was reinstated. It is believed that this was the moment when the marital problems began between Henry and Helen. They argued endlessly about the reinstatement, and by eleven days into their marriage, Helen had ordered her new husband off her property and put Eberhardt in charge of carrying out the order. A few days later, Eberhardt was reappointed as a special deputy sheriff by Sheriff John Kelly of Riverhead. Eberhardt now had the authority to keep Mr. Hemming off the estate, a job he took very seriously.

On the thirteenth day of their marriage, Hemming came by and got into a very nasty argument with Mrs. Hemming and apparently used "a foul epithet" while speaking to her. Helen told her husband she never wanted to see him step foot on Duck Island again, and then she told Eberhardt what her husband had said to her.

A few days after the argument, Henry called the sheriff's office and asked him to obtain a warrant for his wife's arrest. He claimed that she was a bigamist and that she had a husband in between him and Henderson and had never filed for a divorce. Hemming was told by the sheriff that he would have to state his charge against his wife to District Attorney Partridge, which Hemming did. The DA started an investigation and did find out that Helen Hemming had been married to Richard Van Wyck Thorne, a New York City mortgage broker, who had disappeared sometime after 1915. A case had been brought against Thorne, who apparently defrauded a lawyer by the name of Gilbert H. Montague out of $27,000. Thorne was also accused of forging a loan. It is unknown why Thorne went missing or if he was ever found, but maybe that was the reason why Helen had never gotten a divorce. Whether Helen was ever charged with bigamy is unknown.

Eventually, Henry made the attempt to reconcile with his wife. Eberhardt, meanwhile, warned Mrs. Hemming that if Mr. Hemming tried to enter her house, he would kill him. This was a threat Mrs. Hemming did not take lightly.

Six weeks into their marriage and five hours before the killing, Henry and Helen seemed to be on somewhat better terms and were at Henry's apartment at 310 West Eighty-Sixth Street in New York City. Helen wanted to go back to the house on Duck Island, but she told Henry that she did not

want him coming with her. She told him the threats the gardener had made, but Henry scoffed at the warning and insisted on coming with her. They took Henry's car and chauffeur to Long Island and stopped at a hotel in Centerport that evening so Helen could make a phone call to her home on Duck Island. She spoke to her daughter and told Eberhardt that Henry was accompanying her to the house.

Helen said again that she was quite certain the gardener would kill him if he stepped on the property. Still, Henry did not believe it and actually laughed it off. Trying to buy some time, Helen agreed to have a late dinner with her husband at Hall's Roadhouse in Centerport. She insisted, yet again, that she did not want him to accompany her to the house, warning him that the gardener would try to kill him. Henry would hear nothing of it, and before long, they were driving down the desolate roads to the house on Duck Island.

The chauffeur, not having an inkling of any potential situation, did notice that Mrs. Hemming seemed nervous as they approached the house. Meanwhile, Eberhardt warned Helen's little girl that if her stepfather came onto the property, he would shoot him. When the car came to a halt at the house, Henry helped his wife from the car as Eberhardt made his way out the screened door and onto the porch, where he stood on the top step, holding a revolver in his right hand. The child and the butler stood behind him. Eberhardt said nothing as he watched Mr. and Mrs. Hemming make their way toward the porch. It wasn't until Henry put his foot on the first step that Eberhardt began to speak: "Don't you come up on this porch. Mrs. Hemming has told me she doesn't want you to enter this house now or any other time. If you come up those steps, I'll shoot you."

Mr. Hemming replied, "This is my wife, and it's her home, not yours. I don't care for your pistol. I dare you to shoot."

With that, Mr. Hemming started to make his way up the steps. The gardener, without saying another word, pointed the gun at Henry and fired two shots. Mr. Hemming fell to the grass, the bullet passing through his watch on his waistcoat pocket and penetrating his abdomen. Mrs. Hemming ran to her husband's side while the chauffer, butler and young Helen looked on in horror. No one went to help Mrs. Hemming with her husband because they were terrified the gardener would shoot again. Mrs. Hemming then ran up the stairs past Eberhardt, and as she rushed in the house to telephone the doctor, the gardener took two more shots at her husband.

In describing the shooting, a *New York Times* article wrote, "One bullet struck the dying man under the right ear and passed through his neck and

The scene on Duck Island, where Henry Hemming was shot by the gardener while his new bride looked on. *Sketch by Joan Harrison.*

out under the left ear. The third bullet merely grazed the scalp, passing through the broker's straw hat, which had not fallen from his head."

After shooting Mr. Hemming, Eberhardt walked into the house. Seeing Mrs. Hemming dialing the phone, he said to her, "Mrs. Hemming, I want you to take care of your little daughter there. Goodbye, Helen, and everybody else. Goodbye."

With that, he made his way upstairs to his bedroom and closed the door. The butler ran up after him, but before he could open the door, the sound of another gunshot was heard. The gardener had shot himself through the right temple, the bullet passing through his head and out of the room through a screened window. The butler saw Eberhardt fall from the bed and crash to the floor.

Henry Hemming and Frank Eberhardt were dead, and Duck Island would never be the same.

Mysterious Shooting in Freeport Doctor's Office

FREEPORT

The Dr. Edwin Carman case from 1914 has baffled people for years. A puzzling chain of events led to the murder of Mrs. Louise "Lulu" Bailey while she was having a conversation with her doctor in his office. Was it jealousy? Revenge? Although there was a prime suspect, namely Dr. Carman's wife, she was never charged with the murder. Here is the bizarre story of Dr. Edwin Carman, Louise Bailey and Florence Carman.

Dr. Carman and his wife, Florence, lived at 118 West Merrick Road in Freeport in the year 1914. Their house was large and beautiful, and Dr. Carman ran his practice in a portion of the first floor that had been converted into a doctor's office. The Carmans were respected and well-known citizens in their community, and they had a daughter named Elizabeth.

On the night of June 30, 1914, according to the maid, Celia Coleman, dinner had been served to Dr. Carman; Florence Carman; Mr. and Mrs. Platt Conklin, Florence's parents; and Mrs. Ida Powell, Florence's sister. After dinner, Celia believed the family went to another area of the house and Mrs. Carman went upstairs to her bedroom. It was unknown where Dr. Carman was. Around 8:30 p.m., a shot was heard. A gun had been fired into the first-floor window of Dr. Carman's exam room. Mrs. Louise Bailey, an apparent patient, lay dead on the floor. Autopsy results showed that the bullet had entered her body near her right shoulder. It then went diagonally through her body and into her left breast. She died almost immediately. The bullet came from a .38-caliber pistol.

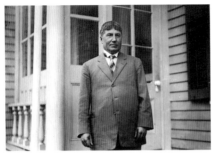

Above: Dr. Edwin Carman in Freeport.
Courtesy of the Library of Congress.

Right: A portrait of Florence Carman.
Courtesy of the Library of Congress.

According to Mrs. Jennie Duryea, the victim's mother, her daughter had left her house in Hempstead at 3:15 p.m. to visit a friend in Rockville Centre. Louise was not ill, although her eyes were puffy, and Mrs. Duryea suggested she may want to see a doctor. Mrs. Bailey made no mention at all of any plans to go to Dr. Carman's office. William Bailey, husband of the victim, had gone to see a cousin on the night of the shooting. When he arrived home, he discovered that his wife was not at home. A bit concerned, he stayed up and waited for her. A short time later, he received a call that his wife had been murdered. He was devastated.

Like Mrs. Duryea, Mr. Bailey, a bookkeeper in New York City, said his wife had not been ill and that she had never mentioned Dr. Carman. It is believed that Dr. Carman may have been introduced to Louise by a female cousin of the Baileys seven weeks prior. However, when the cousin took the stand at trial, she did not admit that. Instead she said that Louise may have met Dr. Carman at her house a year ago. At the trial, when Dr. Carman was asked if he knew Mrs. Bailey, he said that the night of the murder was the first time the woman had ever been to

his office. She was in the office for eight to ten minutes. He did not recall meeting her a year earlier.

The first question was why was Louise Bailey at the office of Dr. Carman? Was Dr. Carman lying? Had he seen this woman before?

There had been times prior to the murder when Florence had reason to believe that her husband had been cheating on her with his female patients. On one occasion, she caught him giving money to a nurse and then saw him kiss her. At the trial, Dr. Carman denied the charges but did claim that his wife had burst into the room recently while he was with a female patient and that she had made a scene and slapped the patient's face and pulled her hair.

What Dr. Carman did not know was that his wife, being suspicious of him, had a Dictaphone installed in the house so she could listen in on his conversations with his female patients. The installer, who was a witness at the trial, told the jury that when Mrs. Carman first came to him, she lied about her reasons for wanting the Dictaphone. He knew she was lying and questioned her. At that point, Mrs. Carman told him about what she believed was going on. The installer asked her why she would not divorce him, and she told him it was because of her daughter that she was staying with him.

Police did a thorough search of the Carmans' house after the shooting and discovered the Dictaphone. It had been hidden in the attic. They also found a box of .38-caliber bullets. The box the bullets were in was coated with heavy dust. Authorities believed it was coincidental that the same bullets were found in the attic. However, everything else led to Mrs. Carman being the shooter. She was arrested a week later and sent to the Nassau County Jail in Mineola.

Many witnesses were called to testify at the trial, which became quite sensationalized. Ellwood T. Bardes, an insurance agent, was an eyewitness in the trial. He claimed that on the night of the murder, he had planned to make a professional call to Dr. Carman's office for a minor injury he had incurred. He left his house, which was not far away, and started walking over to Dr. Carman's office around 7:30 p.m. By the time Bardes got to the doctor's office he decided he didn't want to pay the doctor's fee and that he could dress his wound himself. He turned around and walked past the house, and that's when he heard an explosion. At first he thought it was a blown tire on an automobile, but as he turned and looked toward the street, there was nothing there. He then looked back at the house and saw a tall, well-built woman wearing a dark skirt and a light shirtwaist. She was not wearing a hat. He watched the woman, who he claimed "was in a

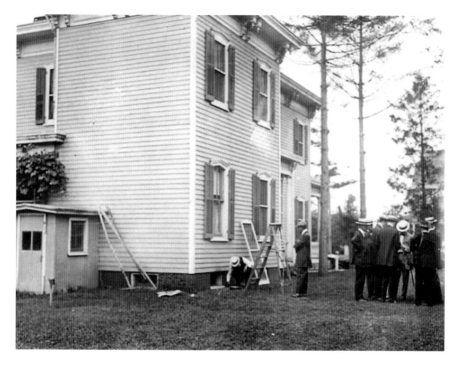

Police conducting a murder investigation at the Carman home in Freeport. *Courtesy of the Library of Congress.*

hurry," move away from a window at the side of the doctor's office toward the rear of the house.

Next were witnesses George Golder and Archie Post, who were in the waiting room when the shot was heard. Conflicting newspaper reports state that the witnesses saw Mrs. Carman enter the doctor's office almost immediately after the shooting, while another source states the witnesses saw a "lady in white" standing on the porch after the shooting. There were so many newspaper articles written from all over the country, which makes authenticating the stories challenging. Another article stated that in addition to the men, there were two female patients in the waiting room as well, but they disappeared after the shooting and no one knew who they were. It is interesting that Dr. Carman had so many patients that night after hours.

Then there was the maid, Celia Coleman, who changed her story several times in court, oftentimes claiming that she "did not remember." Celia had been living in Freeport for two months and had been employed by the Carmans for about a month and a half at the time of the murder. During

her original testimony, Celia stated that Mrs. Carman had been inside the house the entire time and that she had never gone onto the porch. It is believed Celia may have been covering for Mrs. Carman. At a later trial date in October, Celia changed her story and said that Mrs. Carman did go out to the porch from the back door and that she had a shawl on and seemed to be carrying something hidden underneath. In still another statement, she said Mrs. Carman admitted the shooting to her. Cecilia turned out to be an unreliable witness in the case. It was said that she had made five different statements since the night of the shooting.

Another witness, Frank J. Farrell, was new to Freeport and was considered a tramp. He was hungry and was walking along looking for food and work. He came upon the Carman house on the evening of June 30 and saw a light on in the house toward the rear. He was making his way along the side of the house when he saw "a tall woman in a kimono with a shawl about her shoulders." He claimed he saw the woman smash a windowpane and then heard a shot. He became frightened and ran away, not knowing or understanding what the woman was doing. He read about the case in the paper a few days later and decided to come forward.

In another bizarre twist, six days after the shooting, on the night of July 6, 1914, Dr. Carman was riding in a car with a Manhattan actor by the name of Garland Gaden. As they rode down Centennial Avenue at 10:00 p.m., a man on a bicycle took three shots at the car. Dr. Carman was convinced that someone was trying to kill him. According to the *Chicago Tribune*, "Two of the three shots struck the closed body of the physician's car, showing that the aim was fairly good. At least two of the shots were fired at a distance of twenty or thirty feet."

Dr. Carman said it was so dark out that he could not get a good look at his would-be assassin. Although the sheriff and other authorities found the

Celia Coleman, the Carmans' maid, heading to court to testify. *Courtesy of the Library of Congress.*

125

story of the three shots to be "very interesting," they firmly believed that something was going on to "divert the attention of the authorities, the press and the public" and that the incident was taking away from the matter at hand, which was the murder of Mrs. Bailey.

The Carmans' attorney, on the other hand, believed the murder and the shots fired at Dr. Carman's car were related and that someone was trying to kill Dr. Carman. He believed the incident was pertinent to the investigation and that not enough attention was being paid to it.

The trial continued for weeks with no substantial evidence and a lot of conflicting stories. It ended in a hung jury, and another trial was set for October. A young lawyer from Freeport named Morton Levy took over the case on a retrial. He ended up discrediting several of the witnesses, and the trial finally ended with Mrs. Carman being acquitted.

It is said that after the final trial, Dr. and Mrs. Carman reconciled any differences they may have had and continued to live out their lives in Freeport.

It was never determined who shot at Dr. Carman's car, nor was Mrs. Bailey's murderer ever found. To this day, many people believe that the revolver lies beneath the water in one of Freeport's canals—the mystery of the Carman case never solved.

Captain Carpenter Murdered at Sea

GLEN COVE

The Carpenter family was a well-known, seafaring family from Glen Cove and can be traced back to ship owners from the 1740s through the 1800s. Thomas Carpenter was born on August 20, 1838, on the family homestead, and like the generations before him, he was brought up with the sea.

Captain Carpenter had a great deal of misfortune in his life. Thomas attended a rally in New York City with his brother George in September 1862. It was there that Thomas, who was just a teenager, enlisted in the Union army's Fifth Heavy Artillery, Company C, where he served for only one year. Even at his young age, Thomas was afflicted with a chronic kidney ailment, as well as rheumatism. Several of his details took place overnight in the rain, which did not help his condition, so he was discharged in September 1863.

Shortly thereafter, he married a young woman from Syosset, Elizabeth Velsor, and the two headed back to Glen Cove to live. Thomas was a hard worker, and he quickly worked his way up to senior skipper of his Uncle James S. Carpenter's schooner the *Long Island*. Life was good for a while until his daughter Aida died at eight months old in September 1865. Thomas was heartbroken. Things got much worse a year later in 1866, when his wife, Elizabeth, died of consumption. Two years later, in 1868, he married Hannah Strong in New York City, but that ended eight years later in divorce when Thomas found out that Hannah had been cheating on him. Thomas married yet a third time, this time to Christina Nielson, who was only

sixteen years old. Thomas was thirty-eight by this time, and their marriage was a rocky one. The couple struggled financially and lived with Christina's parents. Thomas developed a bit of a drinking problem, and when he wasn't out to sea for long periods of time, he was drinking down at the piers with his friends. This was not very conducive to a happy marriage. He and Christina separated in 1884 but never divorced.

Thomas took to living on his uncle's ship, and despite all his difficulties, he still dreamed of owning his own ship and business one day. Little did he know that he would not live to see his dreams come to pass.

On Sunday morning, November 21, 1886, Glen Cove resident C.L. Perkins was walking along the beach at the mouth of Hempstead Harbor not far from Garvies Point when he noticed a schooner washed up along the beach with all its sails raised. Curious, he walked toward the vessel and started shouting to see if anybody was there. When no one replied, he boarded the ship and found it empty. He discovered bloodstains on the schooner's deck and immediately contacted the authorities.

Upon investigation, more blood was found in various areas of the ship, including on the tiller rope and on the captain's seat near the wheel. There was damage between the wheel and the rail and on the side of the boat, and a six-foot stick was found broken nearby. It was believed that a struggle had taken place and that the body of Captain Carpenter was thrown overboard. There was evidence on the deck that someone had tried to mop up the blood. The captain's clothing and money were missing, as was a yawl boat. What was also odd was the location of the boat. The area where the vessel came to shore was very rocky, so it was unlikely that it had drifted to shore on its own because there was no damage to the hull. It looked as if it had been placed there by someone who knew how to sail it in.

At the stern of the boat, a pair of trousers were found with specks of blood and clay on them. It was discovered that the trousers belonged to Seaman Henry Francke, who also happened to be the last person to see Thomas Carpenter alive. Apparently, they were seen together on the *Long Island* the night before the captain's disappearance. Francke was on the last voyage with him, and they were seen together on the schooner shortly before it left the dock at Jay Street in North River. They had just delivered a load of clay and sand from Glen Cove.

Francke was found at his mother's house in Greenpoint, Brooklyn, and was brought in for questioning. He declared his innocence in the following statement:

I shipped with Captain Carpenter two months ago. I had a disagreement with Captain Carpenter about my pay when we left Glen Cove for New York City on Thursday last. I told him that I would leave him unless I get more pay. I received my month's wages after we arrived in New York City, then I left the schooner. On Saturday, I went to Jay Street Pier where the schooner was lying to see if the captain would give me more pay. He wouldn't, so I went away. He then took the schooner out alone. I went off to my sister's house and slept the Saturday night there and to my mother's on Sunday. I know nothing of what has come of Captain Carpenter.

News of the captain's disappearance started to spread, and one man, Captain Peters of the tugboat *Glen Cove*, came forward to say that he had seen Captain Carpenter on the *Long Island* off Sands Point, about five miles west of where the schooner was found. Peters said he saw Carpenter at the wheel and that he did not see anyone else on board. Unfortunately, his information did nothing to help solve the case.

The mysterious death of Captain Thomas Carpenter. *Sketch by Joan Harrison.*

Because of the lack of witnesses and evidence, there was nothing that could prove that Francke was involved in the disappearance and possible murder of Captain Carpenter. Authorities had no choice but to believe that Carpenter was ambushed by pirates who robbed him and threw him overboard. A fifty-dollar reward was offered to anyone who could recover Captain Carpenter's body. He was described as forty-eight years old, with gray hair and a mustache, five feet, eight inches tall and weighing 180 pounds. The search went on, but to no avail.

Six months later, on May 28, 1887, some local fishermen were walking along the beach to their favorite fishing spot on the northern shore of Glen Cove called Matinecock when they made a horrifying discovery. There, along the shoreline, was a body with one leg and one arm missing. When the police arrived and the body was examined, it was determined that it was indeed the missing Captain Carpenter and that he had been shot seven times. As for his missing arm and leg, the examiner said they more than likely were eaten away by fish. Other evidence revealed that the body had been anchored down by the perpetrators. A dollar was found in a pocket.

Captain Thomas Carpenter was survived by his parents, three brothers, four sisters and his wife, Christina. A small, private funeral took place, and the captain's remains were interred in a family plot in Sea Cliff. The murderer was never found.

Many believed that Henry Francke was the true murderer, but it could never be proven. Many years later, while Francke was on his deathbed, he made a chilling confession. He said it was him, in fact, who had killed Captain Carpenter on that November day. He claimed that he had been tortured throughout his life because the ghost of Captain Carpenter had haunted him for years.

Bibliography

Adirondack Daily Enterprise. "Rockefeller to Hear Pleas for Lives." N.d.

Annibell, Wendy Polhemus. *A Trial in East Hampton, 1650's.* Riverhead, NY: Suffolk County Historical Society, 2016.

Bend (OR) Bulletin. "Kidnap Case Is Unsolved." August 27, 1937.

Bradford (PA) Era. "Found Guilty of Murder." December 18, 1887.

Brooklyn Daily Eagle. "Bloodstained Tuthill Clues Found in Wood." August 28, 1932.

————. "Corn Doctor with 4 Guns Oddly Missing." August 8, 1932.

————. "Mrs. Carman Asks to Tell Her Story to End Suspicion." July 3, 1914.

————. "Mrs. Carman Under Arrest; New Witness." July 8, 1914.

————. "Saw Woman Break Carman Window, Says Witness." July 15, 1914.

————. "Seek Third Man Now in Murder of 'Doc' Tuthill." August 24, 1932.

————. "Servant Grilled on Every Move of Mrs. Carman." July 6, 1914.

————. "Want Thorne as Forger." December 27, 1915.

Brosky, Kerriann Flanagan. *Huntington's Hidden Past.* Huntington, NY: Maple Hill Press, 1995.

————. *Huntington's Past Revisited.* Huntington, NY: Maple Hill Press, 1997.

Carr, Edward A.T. *Faded Laurels: The History of Eaton's Neck and Asharoken.* Interlaken, NY: Heart of the Lakes Publishing, 1994.

Chicago Daily Tribune. "Assassin Fires on Dr. Carman." July 6, 1914.
———. "Mrs. Carman, in Jail, Collapses." July 9, 1914.
———. "Seeks His Wife; Shot by Mother." July 14, 1908.
1880 United States Federal Census. Islip, NY, June 15, 1880.
Emery, Frank. "Mitzie Downs Says Husband Is Innocent." *Brooklyn Daily Eagle,* November 1, 1932.
Fitchburg (MA) Sentinel. "Murdered His Mother: The Crime of Young Asbury Hawkins Who Hangs Today." December 11, 1888.
Galveston (TX) Daily News. "An Islip Murder Mystery, the Mutilated Body of a Woman." October 4, 1887.
Good, Bill, Jr. "Captain Kidd Visits Gardiner's Island." *East Hampton Star,* June 25, 1998.
Hempstead (NY) Sentinel. "Mrs. Bailey Shot in Dr. Carman's Office." July 2, 1914.
Jensen, Bill. "Murder on the Long Island." *True Crime; L.I. Confidential,* n.d.
———. "A True Crime Tour." *Long Island Voice* 2, no. 27 (October 15–21, 1998).
King, Hugh R., and Loretta Orion. "Witchcraft in the Founding Days of East Hampton." Transcript of lecture, May 9, 1998.
Krieg, Joann P. *Long Island Studies: Evoking a Sense of Place.* Hempstead, NY: Long Island Studies Institute at Hofstra University, 1988.
Los Angeles Herald. "Body Decapitated." September 28, 1902.
———. "Murderer Dies in the Electric Chair." March 15, 1904.
New York Times. "Boy's Jealousy Ends Two Lives." September 5, 1911.
———. "Broker Is Slain at Bride's Door by Her Gardener." July 16, 1921.
———. "The Brookville Murder." December 2, 1883.
———. "Conference Called in Hemming Slaying." July 31, 1921.
———. "Dr. Simpson Shot by His Victim's Widow." July 14, 1908.
———. "Hanging of Charles H. Rugg." May 16, 1885.
———. "The Long Island Mystery." November 23, 1886.
———. "Slain by Her Own Son: The Murderer of Mrs. Hawkins Quickly Found." October 4, 1887.
———. "State Meets a Check in Simpson Murder Trial." February 6, 1907.
———. "The Trial of Young Hawkins." December 6, 1887.
Paris, Linda. "Hamptons History: The Sensational Case of the Corn Doctor." 27east.com, powered by the *Southampton/East Hampton Press,* May 23, 2011.
———. "Noir Crime: The Mad Killer of Suffolk County." 27east.com, powered by the *Southampton/East Hampton Press,* July 2, 2012.

———. "The Strange Saga of Victor Downs." *Southampton/East Hampton Press*, Columbus Day 2013.

Patchogue (NY) Advance. "Mad Killer Suspect." August 13, 1959.

Pettey, Tom. "Question Kin of Slain Girl, Clew in London to Faithfull Death Puzzle." *Chicago Daily Tribune*, June 12, 1931.

Rattroy, Jeannette Edwards. "Pirates and Prohibition." *East Hampton History.* Garden City, NY: Country Life Press, 1953.

Renner, Tom, and Lou Schwartz. "Long Island Mad Killer Strikes a 3rd Time." *Newsday*, August 1959.

San Francisco Call. "Young Woman Shot by Rich Man's Son." September 5, 1911.

Suffolk County News (Sayville, NY). "Confessed Killer." August 20, 1959.

———. "Dr. Simpson Shot." July 17, 1908.

———. "Mrs. Parsons Dead, Surrogate Rules." June 14, 1946.

———. "Murder and Suicide." September 8, 1911.

Sunday Tribune (Terre Haute, IN). "Tobin Placed on Trial." December 14, 1902.

Wynn, Judith. "The Ill-Fated Society Girl, Again in Fiction." *Baltimore Sun*, December 8, 1994.

Web Resources

Bendici, Ray. "Elizabeth Garlick." Damned Connecticut, November 2012. www.damnedct.com/elizabeth-garlick.

Blogspot.com. "Starr Faithfull in New York." January 24, 2008. starrfaithfull. blogspot.com/2008/01/starr-faithfull-1906-1931.html.

Brooklyn Standard Union. "Starr Faithfull." Death notice, June 9, 1931; "Action Hints New Clues to Starr's Death." June, 11, 1931; "Cabby Reveals Drinking Tour of Long Island," June 13, 1931. starrfaithfull.blogspot. com/2005/08/starr-faithfull-brooklyn-standard.html.

Carpenter, John L. "Murder on the High Sea." Long Island Genealogy. longislandgenealogy.com/murhigh.html.

Crocker, Betty. "What Really Happened to Starr Faithfull?" Crasstalk.com, March 13, 2011. crasstalk.com/2011/03/what-really-happened-to-starr-faithfull.

Findagrave.com. "Thomas Dunham Carpenter." www.findagrave.com/cgi-bin/fg.cgi?page=gr&Grid=16005649.

Forensic Science Lab Activity. "Murder at Old Fields." 2017. murderatoldfields.com/site/about_the_crime.

Freeport Long Island History. "Carman Murder." freeportlihistory.blogspot. com/2007/07/murder-and-mayhem.html?spref=pi.

Genealogy.com. "Genealogy Report: Descendants of Richard Lettin." www. genealogy.com/ftm/c/a/r/John-L-Carpenter/GENE17-0025.html.

Greenlawn-Centerport Historical Association. "John Gardiner Farm." 2017. www.greenlawncenterporthistorical.org/john-gardiner-farm.

Hanc, John. "Before Salem, There Was the Not-so-Wicked Witch of the Hamptons." Smithsonian.com, October 25, 2012. www.smithsonianmag. com/history/before-salem-there-was-the-not-so-wicked-witch-of-the-hamptons-95603019.

Hughes, Robert C. "Vernon Valley Violence." Huntington History, February 25, 2012. huntingtonhistory.com/2012/02/25/vernon-valley-violence-3.

JUSTIA US Law, United States of America Ex Rel. Francis Henry Bloeth, Relator-appellant, v. Wilfred Denno, as Warden of Sing Sing State Prison, Ossining, New York, Respondent-appellee, 313 F.2d 364 (2d Cir. 1963). law.justia.com/cases/federal/appellate-courts/F2/313/364/317857.

Kimster. "Alice Parsons: Heiress, Long Island, 1937." Web Sleuths, August 6, 2007. www.websleuths.com/forums/showthread.php?52125-NY-Alice-Parsons-Heiress-Long-Island-1937.

Mann, Nolan. "Long Island's Own Witchcraft Trial, 1657." Sayville-Bayport Patch, November 5, 2010. patch.com/new-york/sayville/long-islands-own-witchcraft-trial-1657.

Millo, Tennille Lynn. "Hunting for 'Hauntings' in Long Beach." Long Beach Patch, October 27, 2011. patch.com/new-york/longbeach/ghosts-of-long-beach-past.

Montauk Chamber of Commerce. "The History of Montauk." 2017. www. navybeach.com/about-us/montauks-history.

Murder by Gaslight. "Murder by Gaslight—The Long Island Murders." September 20, 2014. www.murderbygaslight.com/2014/09/the-long-island-murders.html.

Mysterious Stories, True Crime. "The Dictaphone Murder Trial of 1914: A Mystery in Pictures." July 16, 2014. www.boweryboyshistory. com/2014/07/the-dictophone-murder-trial-of-1914.html.

New England Historical Society. "The Mysterious Death of Starr Faithfull Reveals a Boston Mayor's Sordid Secret." www. newenglandhistoricalsociety.com/the-mysterious-death-of-starr-faithfull-reveals-a-boston-mayors-sordid-secret.

Ortega, Gena Philibert. "Investigating the Murder Mystery of Louise Bailey." Genealogy Bank, June 28, 2013. blog.genealogybank.com/investigating-the-murder-mystery-of-louise-bailey-with-newspapers.html.

People v. Tobin. New York Court of Appeals, October 1903. casetext.com/case/people-v-tobin.

Rattiner, Dan. "Captain Kidd: Pirate Buried Treasure on Gardiner's Island." Dan's Papers, February 7, 2016. www.danspapers.com/2016/02/captain-kidd-pirate-buried-treasure-on-gardiners-island.

———. "Goody Garlick: The True Story of the Woman Tried for Witchcraft in East Hampton." Dan's Papers, November 1, 2012. www.danspapers.com/2012/11/goody-garlick-the-true-story-of-the-woman-tried- for-witchcraft-in-east-hampton.

Stark, Ian. "Secrets of Oyster Bay: Captain Kidd, Ghost Vortex and More." Newsday, January 3, 2017. www.newsday.com/lifestyle/recreation/secrets-of-oyster-bay-captain-kidd-s-downfall-ghost-vortex-more-1.11516099.

Strange Company Blogspot. "Starr Crossed." March 14, 2016. strangeco.blogspot.com/2016/03/starr-crossed.html.

Time magazine. "Why the Media's Been Faithful to Starr Faithfull." August 23, 2005. starrfaithfull.blogspot.com/2005/08/why-medias-been-faithful-to-starr.html.

Index

About the Author

Thomas Decker Studio.

Eight-time award-winning author and historian Kerriann Flanagan Brosky has been featured in numerous publications, including the *New York Times*, *Newsday* and *Distinction* magazine. She has appeared on CBS's Sunday morning show, *Ticket*, with Laura Savini, News 12 Long Island, and *The Thinking Writer* in East Hampton for her previously published nonfiction books. Kerriann served on the board of trustees as first vice president for the Huntington Historical Society for six years and served as a trustee for the Greenlawn-Centerport Historical Association for three years. Kerriann is the recipient of the Top Advocate for Historic Preservation and Education award from the Oyster Bay Historical Society, the Huntington Heritage Education award from the Town of Huntington and the Woman of Distinction award from the New York State Assembly. Kerriann is an advisory board member for *Everything Old Is New Again* radio show. She is currently a contributing writer for *Edible Long Island*, where she has her own column, "Kerriann Eats." Kerriann is president emeritus of the Long Island Authors Group and is a well-known

speaker who draws standing room–only crowds to her lectures. Kerriann lives in Huntington, Long Island, and when she's not writing, she enjoys spending time at the beach with her husband, Karl, and their two sons. Please visit her website at www.kerriannflanaganbrosky.com.